Picasso

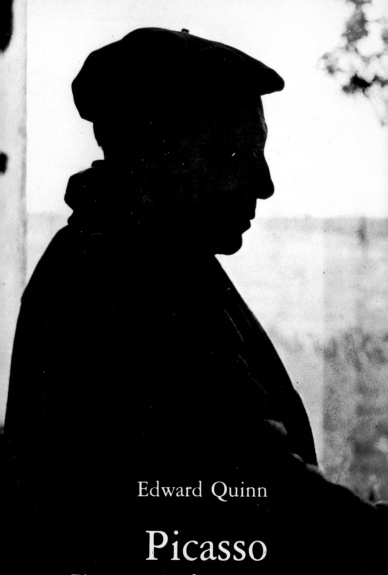

Edward Quinn

Picasso

Photographs from 1951–1972

BARRON'S

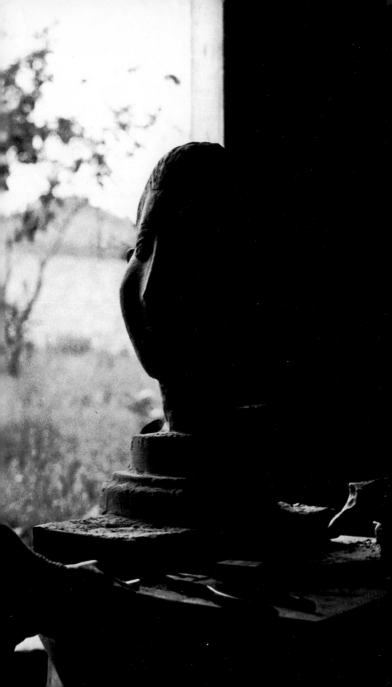

Translator: Donna Pedini Simpson

Front cover photograph: Picasso with his youngest daughter, Paloma.

Back cover photograph: Flirting with charm, Picasso poses with Mme. Weisweiler in the garden of her villa, Santo Sospiro.

Title pages: At La Fournas Atelier (a former perfume factory) in Vallauris, Picasso critically examines the plaster cast of the sculpture, *Head of a Woman,* 1951.

© Copyright 1980 by Barron's Educational Series, Inc., solely with respect to the English language edition.

© Copyright 1977 by DuMont Buchverlag, solely with respect to the German language edition.

© Copyright for all photographs by Edward Quinn.

All rights for all countries reserved by DuMont Buchverlag GmbH & Co., Kommanditgesellschaft, Cologne, West Germany.

The title for the German Edition is:

PICASSO
by Edward Quinn

All inquiries should be addressed to:
Barron's Educational Series, Inc.
113 Crossways Park Drive
Woodbury, New York 11797

Library of Congress Catalog Card No. 80-11462
International Standard Book No. 0-8120-2109-6

Library of Congress Cataloging in Publication Data
Quinn, Edward.
 Picasso.
 Translated from the German.
 1. Picasso, Pablo, 1881–1973 — Portraits, etc.
2. Painters — France — Biography.
ND553.P5Q5213 759.4[B] 80-11462
ISBN 0-8120-2109-6

PRINTED IN THE UNITED STATES OF AMERICA

 2 3 4 5 6

Contents

Dates of the Photographs 2

The Photographer as Chronicler 3

Vallauris — Picasso's Potters' Village 23

Picasso and Jacqueline 35

Picasso and his Ateliers 55

Friends and Visitors 85

Picasso and his Children 102

Toros y Toreros 114

Posed Photos 123

Biography 135

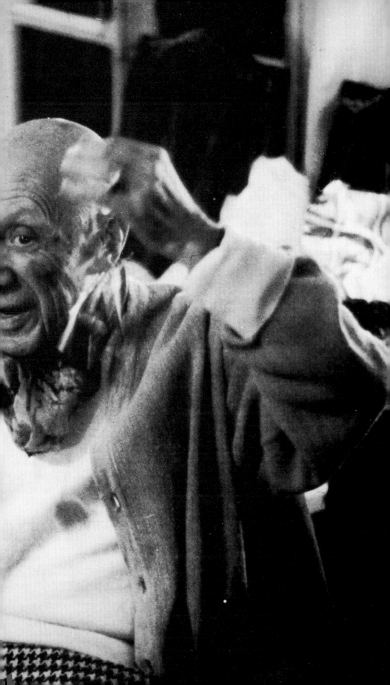

Dates of the Photographs

PHOTO	DATE	PLACE	PHOTO	DATE	PLACE
Title Page	1953	La Fournas, Vallauris	59–68	1955	Filmstudios de la Victorine, Nice
1	1972	Le Mas Notre Dame de Vie, Mougins	69–72	1961	La Californie, Cannes
2–4	1961	La Californie, Cannes	73–74	1959	Saint Jean — Cap Ferrat
5–10	1959	La Californie, Cannes	75–78	1959	La Californie, Cannes
11	1956	La Californie, Cannes	79	1961	La Californie, Cannes
12	1954	La Galloise, Vallauris	80–81	1956	La Californie, Cannes
13–14	1953	La Galloise, Vallauris	82	1959	La Californie, Cannes
15–17	1953	La Fournas, Vallauris	83	1966	Antibes
18–23	1953	Madoura Pottery, Vallaris	84	1956	La Californie, Cannes
			86–88	1956	La Californie, Cannes
24–25	1966	Le Mas Notre Dame de Vie, Mougins	89–90	1953	Villa La Galloise, Vallauris
26	1960	Château de Vauvenargues	91	1959	Blue Bar Restaurant, Cannes
27	1961	La Californie, Cannes	92	1951	Vallauris
29–30	1956	La Californie, Cannes	93–95	1954	Golfe-Juan
31	1959	La Californie, Cannes	96–101	1953	La Galloise, Vallauris
32	1961	La Californie, Cannes	102–105	1955	La Californie, Cannes
33	1960	La Californie, Cannes	106–108	1960	La Californie, Cannes
34	1957	La Croisette, Cannes	109–110	1959	La Californie, Cannes
35	1964	Nice Airport	111	1960	Arles
36	1964	Le Mas Notre Dame de Vie, Mougins	112	1955	Vallauris
			113	1959	Arles
37	1953	La Fournas, Vallauris	114	1955	Filmstudios de la Victorine, Nice
38–39	1959	La Californie, Cannes			
40–42	1953	La Fournas, Vallauris	115–116	1953	La Galloise, Vallauris
43	1956	La Californie, Cannes	117	1953	La Fournas, Vallauris
44–49	1961	La Californie, Cannes	118	1953	Madoura Pottery, Vallauris
50	1960	La Californie, Cannes			
51	1961	La Californie, Cannes	119–120	1956	La Californie, Cannes
52	1960	La Californie, Cannes	121	1965	Le Mas Notre Dame de Vie, Mougins
53	1960	Château de Vauvenargues	122–125	1956	La Californie, Cannes
54–55	1962	Le Mas Notre Dame de Vie, Mougins	126	1955	Filmstudios de la Victorine, Nice
56	1966	Le Mas Notre Dame de Vie, Mougins	127	1964	Nice Airport
57–58	1961	Le Mas Notre Dame de Vie, Mougins			

◁ 1 The photo was taken during my last visit with Picasso in Mougins, on January 7, 1972. Picasso is checking the tone of a small bell that I brought him.

The Photographer as Chronicler

The pictures in this book were taken over the course of more than 20 years at various occasions and places in the south of France. They attempt to introduce the reader to Picasso the artist and the man.

The photographs show the "private" Picasso, his houses and studios, children, friends, and animals; they show Jacqueline Roque, his last wife with whom he lived for almost twenty years before his death, and Françoise Gilot, the mother of his children Claude and Paloma.

In 1965, Roland Penrose wrote in the introduction to my book, *Picasso at Work:*

> Although the work of Picasso is more widely distributed throughout the world than that of any living painter, and probably more has been written about him than about any artist who has ever lived, although cameras have recorded thousands, perhaps millions of pictures of him, there remains a desire to know more, a desire which is based on our lack of understanding of how the mind of an artist functions and in what degree his character and his environment are a guide to his achievements.
>
> In this investigation the photographer is useful in ways which are unparalleled in other forms of recording, and when he combines efficiency with tact and understanding he can be of great value in penetrating the hidden and significant events which react on the mind of an artist, as well as giving us an authentic impression of the general atmosphere in which he lives.

I hope that this book will not only be a useful addition to the wealth of material already available on Picasso, but that through the study of his fascinating personality, it will help some readers approach his work.

My first encounter with Picasso was not accidental. After moving to southern France as a professional photographer, I became aware of the fact that Picasso lived close by, and I was eager to meet this man who had always drawn the attention of the international press. Whatever he did was recorded. His name had a magical attraction to newspaper and magazine editors who, to be sure, were delighted when they had the chance to publish something about him, but were only satisfied when they obtained a photograph.

My first opportunity to photograph him came in 1951 at the ceramics exhibition in Vallauris where Picasso had been living and working since 1947. Naturally I was not the only

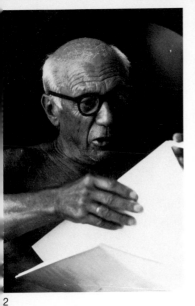
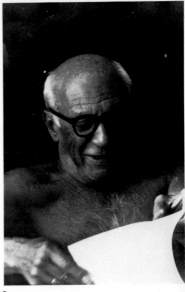

2 3

one who wanted to see Picasso on that day. Also waiting in the crowd of spectators and potters was Prince Ali Khan, another name that produced headlines. Picasso, whom I later learned was not always in a pleasant mood, came to the exhibition smiling amicably, accompanied by his friend, the poet Jacques Prévert. Like a bishop visiting one of his parishes, he strode through the waiting crowd smiling with his head slightly bowed. When he saw potters that he knew, he stopped a few times and spoke with them. Françoise Gilot, his constant companion at that time, followed him inconspicuously, and she engaged in conversation with Prévert. At the entrance to the exhibition the reception committee was awaiting him. Nothing phased him. In the exhibition at last, Picasso, the passionate craftsman, only showed interest in the objects. He carefully examined the

4 ▷

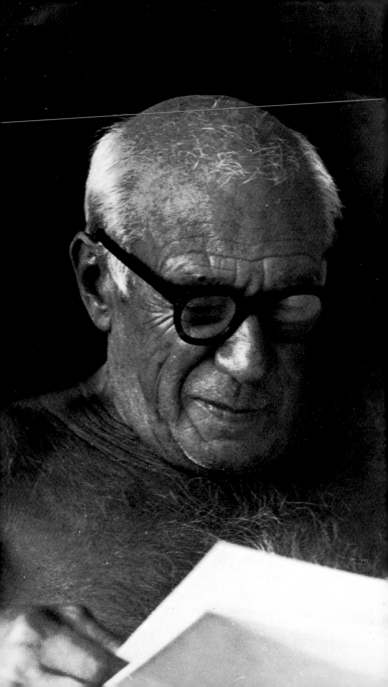

ceramics on display and spoke with the potters, discussing firing methods with them.

But Picasso's own work was also on display — plates with bullfight scenes and mythological subjects, the themes with which he had begun his ceramic endeavors under the direction of Suzanne and Georges Ramié. In the mob of photographers I followed Picasso through the exhibition. We pushed and shoved to get a good picture and I had difficulty even trying to photograph. I didn't want to use a flash, and since the light in the exhibition hall was poor, I had to try to stand still in the crush for a longer exposure. When Picasso then began to converse with Ali Khan, it was clear to everyone that the two quite different celebrities wanted to pose for the photographers' flashes for a moment so they would finally be left in peace.

After pictures had been taken, all the photographers rushed to their press agents. I was not under contract, so I stayed. It paid off, for just as Picasso was about to leave, his housekeeper came with his two small children, Claude and Paloma. Spontaneously, I asked Picasso if he would pose for me with his children. He was in a great mood and agreed. Afterwards, we spoke with one another for a few minutes, at which point I asked his permission to photograph him in his house. He politely refused. "We"ll see."

The first few pictures I had made of Picasso and his children pleased him so much that after a few refusals, he did finally agree to allow me to photograph him in his pottery studio in Vallauris.

My first appointment with Pablo Picasso in his pottery workshop was nerve-racking and difficult. I was afraid that my cautious and timid movements between the rows of stacked-up ceramics might disturb him. To me the click of my camera's shutter seemed to resound like thunder in the atelier. Picasso, though, who was sitting beneath the statue

of St. Claude, the patron saint of potters, worked with concentration, deeply engrossed and not even taking note of me.

I was very excited in this atmosphere. Picasso's all-commanding presence, his reputation as an artist, and the fact that I was seeing him at work for the first time spurred me on to preserve those intense, quickly passing moments. I felt secure enough to experiment more than I usually did, choosing different angles, and making use of unusual lighting conditions.

When the workday with Picasso came to an end, I felt very relieved and encouraged upon hearing him say to a friend, "Lui, il ne me dérange pas." (He doesn't disturb me.) Now I knew that I would be allowed to continue photographing Picasso unhindered in the future. And truthfully, from that day on, I remained one of the few photographers allowed to visit and photograph him at work and one of the very few he ever tolerated in his private domain. This gave me the unique opportunity to take Picasso's portrait carefully over many years.

In the beginning, Picasso received his visitors around midday. Later, when his illness required that he rest during the day, his guests would not arrive until late afternoon, around five or six o'clock. This added an extra problem to my work; because I rarely used a flash or floodlights, I often had very poor lighting — especially in winter.

Whenever I was going to visit Picasso, I would carefully plan out everything I would have to do when I was with him. First I got hold of new color film in order to be able to take pictures of his recent work; then I saw to it that all of my cameras were in excellent working order. But on the very day that I was perfectly prepared, Picasso would call it off. For this reason almost all of my visits were unforeseen and improvised. I rarely knew beforehand how Picasso would

receive me, what mood he was in, or who else had just come to visit.

Whenever I went to Picasso's, I stuffed my pockets with different rolls of film, and packed an extra lens in order to be armed for every eventuality. Experience has taught me I could only get interesting and unusual situations on film during a visit if I were prepared for everything, and did not first have to search for film in my bag or fetch a tripod from a different room.

Usually, I didn't find Picasso alone when I arrived. From 1955 on his wife Jacqueline was frequently present. Though Picasso always wanted to first engage me in conversation, I, naturally, wanted to take pictures since at that time my ambitions were those of a photographic reporter intent on getting good photographic documents. So I asked Jacqueline if I might begin as soon as it was all right. She referred me to Picasso who had observed this "clarification of authority" with amusement and smiling assent. He would have been quite amazed, had I, as a photographer, behaved otherwise. He often said a plumber must repair pipes, a painter paint, and a photographer, of course, photograph.

As soon as I began to photograph, he concentrated on his own expression as if he wanted to show his best side. But after a few minutes he was already so preoccupied or engrossed in conversation that he forgot about me completely. That was the exact situation I needed to take candid and believable pictures of him. To this purpose I used my camera like a pencil, taking down Picasso's myriad activities in his familiar surroundings.

Picasso never demanded to see my pictures to, say, censor them before publication. On the other hand, he also knew that I was loyal to him insofar as I only allowed a picture to be printed if it were both a compelling photograph *and* a documentary. Finally, Picasso had so much trust in me, that

9

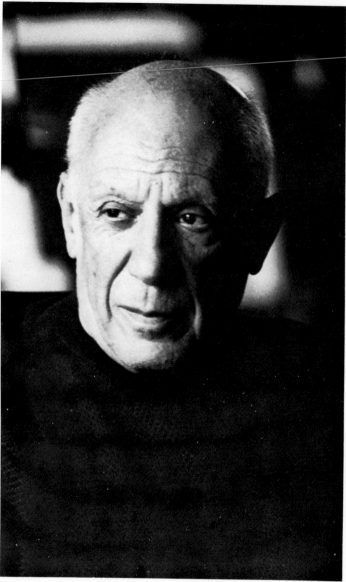

5

he even allowed me into his private domain. Since I did not want to disturb this trust, a conflict naturally arose between my being a friend to Picasso and at the same time being a professional photographer who of necessity had a primary, journalistic interest in "Picasso the object." I decided without much hesitation to remain a friend of Picasso. Nevertheless, when the context of a photographic sequence demanded it, I released pictures which perhaps did not please Picasso at all. He nevertheless tolerated this because he wanted to grant me the freedom I needed for my work.

It has been said that Picasso has been photographed by many photographers who have had a totally different approach than mine. When they had an appointment with Picasso they usually set up their lights in the corners of his atelier and placed their cameras on tripods. Picasso was very impressed by their preparations every time. When everything was ready, he sat or placed himself wherever the photographer wanted. Then the scene was lit to guarantee that particular photographer's style. Picasso's generous attitude toward creative people always granted everyone complete respect in this area and kept him from mixing in. This manner of picture taking never struck me as the kind of true portraiture that would reveal his personality. It remained — even when the photographs were outstanding — stereotypical because it reflected the personality of the photographer more than the person photographed.

My ideas were less pretentious. Picasso preferred them even though the technical results were sometimes not as good. The following episode might illustrate Picasso's attitude toward photography. One of his friends was taking pictures in his atelier. An artist himself, he had altered the arrangement slightly in that he moved Picasso's slippers a little in order to organize the visual composition more advantageously. When Picasso entered the room he noticed

the change immediately. "That will be an amusing photo, but not a documentary. Do you know why? Quite simply because you have placed the slippers somewhere else. I never place them that way. You did that, not I. The way an artist has his things around him is as revealing as his work."

Being alone with Picasso was easy and difficult at the same time. Easy, because we went well together; we both let each other work in peace. Difficult, insofar as I had to weigh how far I could go to obtain the documentary photos I wanted without in the end disturbing Picasso at his work. A few observations I made over the years might be helpful in rounding out Picasso's portrait.

The most striking and fascinating facet to Pablo Picasso's image was the ever-changing manner in which he presented himself. This part of his personality also influenced his moods and work.

When Picasso was in a bad mood (this was usually caused by familial problems or unsatisfactory results in his work), he was unbearable, and nothing was all right with him.

He had a remarkable simplicity in his manner and never acted like the "great genius." On the contrary, he admired the work of others and was interested in everyone. When he showed new work to friends he was very reserved and was delighted with compliments he was clearly not anticipating.

Despite his world renown and his great wealth, Picasso was insecure when in contact with people he didn't know and often helpless with regard to the many problems of daily life. His friend Jaime Sabartés, himself no businessman, often had to advise him on business matters.

Because of his fame, Picasso felt himself in a vulnerable position and always thought he was being criticized. He was proud to be a Spaniard and expected to be valued for his own sake, as an individual, and not because he was a famous, successful, and wealthy artist. He wanted to know everyone's

reason for being interested in him. Though he examined the motives, he was also susceptible to flattery. Nevertheless, he became quickly aware of its superficiality and was irritated at being the way he was. At times he could be cruel, then sensitive again, warm and sympathetic. His charm and amiability often made him irresistible, particularly to women.

Picasso liked people with character; on the other hand, he did not like it when people opposed him too strenuously. He was generous and allowed everyone their freedom as long as this did not disturb him and his work. Nevertheless, his difficult personality never actually allowed him to endure anyone for long, with the exception of his friend Sabartés and his wife Jacqueline.

Picasso's jet black, unmistakable eyes were extremely lively, often piercing, often fiery. They betrayed enthusiasm, curiosity, and alertness. He noticed everything. When he picked up a book, for example, he looked at it as if spellbound. I was often able to observe this unique visual concentration of his, this physical attention when looking at things. Mind and body concentrated completely on what he saw. When he looked at something around him, it almost appeared as though he wanted to use his eyes in the way others would use a magnifying glass, as if he could see beneath the surface of things. With a few precise strokes he outlined all the characteristics of a face and made qualities visible which corresponded to the character of the person portrayed. That he truly perceived what he saw and could record it was Picasso's forte. "I don't paint what I see, I paint what I know," he once said.

This book does not, to be sure, examine Picasso's art from a theoretical point of view; nevertheless, the work of his final years should be addressed briefly. Throughout his entire life, for over seventy years with no great interruptions, Picasso

worked, always striving to become better. At the end of his life he was justified in claiming he could say something about art. In the works he painted during his final years he used a kind of shorthand, a summation of his ideas. He was well aware that he didn't have much more time and strived, by painting and continually repainting a canvas, to further improve it. He wanted to preserve his ideas as quickly as possible, wanted to limit himself to the creative act alone, drawing upon all of his experience. The pictures produced in this vein often appear brittle, as if unfinished (particularly the series of paintings which were on display in the Palace of the Popes in Avignon). Whosoever looks at them more closely, however, discovers the richness in background color, the opulent drawing, and the radiant luminescence of the subject matter. These paintings magnificently unite a creative technique with high artistic standards.

In January 1972 I visited Picasso in Mougins. It was my last visit. I never saw Picasso again. The following notes, which I made at that time, illustrate his lively interest and his vitality — he was, after all, 91 years old.

I was taking pictures for a book on Picasso's ceramic work at the Madoura Pottery. Around half past one I called Picasso's house and Jacqueline answered. She asked me to call again because Picasso was not there. Around half past four I stopped work at the pottery and went to Mougins in order to call from the telephone booths at the post office. The phone was out of order. I went into the post office but there was a long line of people waiting at the window. Irritated, I turned around and ran over to the cafe on the other side of the square to make the call. The cafe was in the process of being decorated, as I found out, because it was opening that evening. I asked if I could make a call and the owner

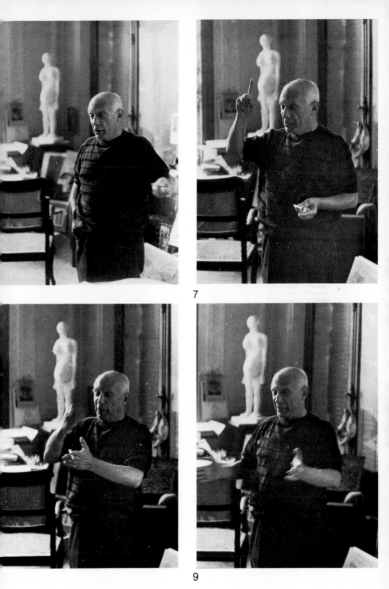

7

9

–10 Gesticulating, Picasso illustrates his thoughts in a conversation with visitors.

10 ▷

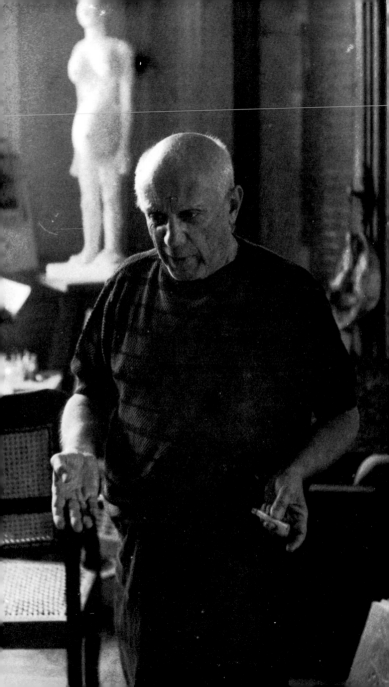

pretended the phone was not yet hooked up. "I only want to make a local call, here in Mougins," I replied angrily and insisted on being allowed to use the phone. He finally gave in and let me call. At Picasso's house Monsieur Miguel, his secretary, answered, and I explained to him that I wanted to complete a movie on Picasso, was preparing an exhibition, and wanted to tell Picasso about it. Monsieur Miguel replied that I should indeed come right away.

At the villa he greeted me and suggested I leave my cameras in the car until it was certain I could photograph. He led me through the long hallway into the living room. There was Picasso sitting with Jacqueline, and Mme. Gagarine, who had taken over the publication of the volumes of Picasso's catalog of works in the *Cahiers d'Art*.

Picasso was happy at my arrival. I told him about my new movie. Suddenly, William S. Rubin, curator of the Museum of Modern Art, came into the room, a tall man with bushy, curly hair. He limped slightly and carried a beautiful walking stick. Everyone sat down, and Picasso leafed through a copy of the new volume of his catalog of works. He commented on a few pictures and was delighted to see others again in reproduction. While he was leafing through it he suddenly said, "I'm really glad I painted them."

Jacqueline offered us *marrons glacés,* and Picasso insisted that everyone try one, including himself. I had begun filming and taking pictures. After Picasso had looked through Mme. Gagarine's layout, I asked him to show me his most recent work. He led me into his atelier which was adjacent to the living room. There he stood beside the *Portrait of a Woman* (1895) by the customs officer Rousseau, which was almost as tall as he himself was. The light was not good, and Picasso tried to turn the picture so it wouldn't reflect. He took great pains and finally placed it just as I

needed to photograph well. Then he brought out a few of his recent drawings, all of which had been produced in the days preceding. Represented were a group of people, a few nudes, a young girl in a realistic style.

Picasso was wearing gray and black check pants, a fawn-colored wool jacket, sweater, and vest. He was in excellent condition, very animated, very active, and his memory was as good as ever. He hurried through the house to find books or work that he wanted to show.

We sat at a large table, and Picasso drank his health tea from a very beautiful cup which, as he proudly announced, was English and from the 18th century. Jacqueline, beside him, was wearing a kimono which further emphasized that austere beauty of hers so often painted by Picasso. Like Picasso, she was also in the best of moods and full of energy for new ideas.

We talked about Picasso's pictures in the Museum of Modern Art, the creation of *Guernica,* and the *Massacre in Korea* which he still had in his atelier. Meanwhile, he fished a reproduction of Cézanne's *Mardi Gras* (1888) out of a mountain of papers and explained he had discovered that Cézanne must have conceived of the entire scene from an elevated position with a forward falling perspective.

Suddenly, he spotted Mr. Rubin's beautiful walking stick, examined it with great attention, and then related that Apollinaire at one time had had a walking stick that suddenly sprouted shoots, blossomed, and became a tree. Both St. Paul and St. Francis, for example, had also had walking staffs which could blossom. Mr. Rubin was greatly amused and asked if the tale of Apollinaire's walking stick might not be a fable. No, it was true that shoots had appeared on his stick, and it had been a sensational opportunity for Apollinaire to show the stick off everywhere.

Jacqueline reported on Picasso's dog Kabul for whom Mme. Leiris had brought along a lady friend so that the then seven year old fellow would no longer have to remain a bachelor. To Picasso's great satisfaction, Kabul had joyfully given up his bachelordom when the opportunity arose, and someone had even preserved the important moment in a photograph.

I had collected a few items for Picasso since my last visit and brought them along. One of them was a small package with "secret" written on it. Picasso became very curious. Because he didn't want to cut the wrapping string, he opened it very carefully and found a puzzle game made out of little chrome tiles which were stuck onto cardboard with adhesive tape. It happened to be arranged very nicely so he left it as it was. I also had a tweed hat with a feather from Moll's Gap near Kenmare, Ireland, and a box of incense. Picasso quickly lit one of the sticks and then another since he liked the scent which slowly drifted through the room. In addition, I also brought him a little Indian bell for hanging on a door or window. He rang it, but finding its tone a little thin, took it, fetched a large bell with a full, somber tone, and quickly asserted that it came from the same place as the small one.

Then he began to play on a stringed instrument that looked like a harp; I think it came from Africa. Jacqueline was of the opinion, however, that he should stop, since he wasn't as good a musician as he was a painter. With that, the conversation turned to Man Ray, whom Picasso, of course, knew quite well. "Man Ray wanted to become known as a painter, not as a photographer," Picasso remarked and maintained that most photographers were jealous of painters and definitely wanted to paint as well. Apparently, they did not consider photography to be creative enough. He told about a photographer who had come to him and taken

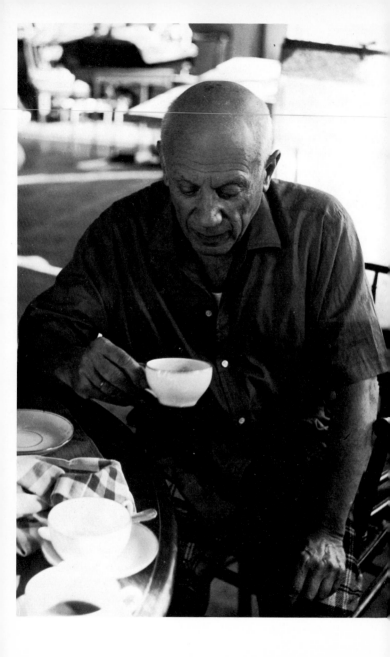

pictures of his sculpture bathed in a colored light. "He was most likely not happy with the sculptures and had thus wanted to make more of them with skillful illumination," said Picasso with amusement.

"He doesn't want to admit to himself how old he really is," Jacqueline interjected, suggesting the end to the visit. "He still thinks he's a young man. When he saw himself in a snapshot with 18 other people recently, he did admit, though, 'I really *do* look like the oldest one here.' "

Mme. Gagarine asked whether he was really still doing sculpture. "Of course, but only at night, when I'm in bed. Then I imagine all the things I could still do and how I would do them." "Yes, he keeps me awake and describes his ideas to me," added Jacqueline.

We all left Picasso together. I shut the garden gate of Mas Notre Dame de Vie behind me. It was 10:03 P.M., January 7, 1972.

Picasso and I talked on the phone again a few days before his death. His voice sounded strange, and I had the feeling something wasn't right. He said that we had to get together again soon. These words were very important to me for they confirmed our friendship. I had not been to his house in over a year. Picasso didn't want to be photographed anymore. He had changed. He died April 8, 1973.

◁ 11 At the dining and worktable in La Californie, Cannes.

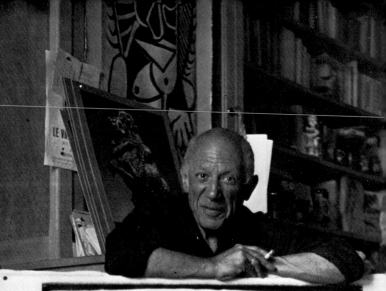
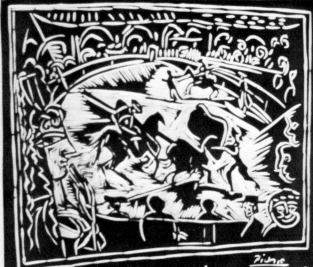

TOROS EN VALLAVRIS
1954

Vallauris — Picasso's Potters' Village

In Vallauris Picasso experienced a period of euphoria with Françoise Gilot and his children Claude and Paloma. He had visited this village of potters in 1946. Deeply impressed by the possibilities of ceramics, he had quickly given himself over to pottery so completely that he decided to move to Vallauris. He bought La Galloise, a small Provençal house situated in the hills above the town. From then on the house and the garden with mulberry and lemon trees, red and white laurels, pines, mimosas, and agaves appeared in many paintings.

A few days earlier I had taken my first pictures of Picasso at the ceramics exhibition in Vallauris. Now I had to show Picasso the pictures and convince him to allow me to photograph at his place for a few hours. So I went up to Vallauris and waited at the garage where Picasso's magnificent antique car, a Hispano-Suiza cabriolet, was parked. Soon thereafter Picasso came down the footpath, accompanied by his oldest son, Paul. Because I only spoke French poorly at the time, I was somewhat ill at ease and didn't quite know how I should begin a conversation with him. I nodded to him amiably and he nodded back equally amiably. "He seems to be somewhat reserved," I thought. "Perhaps he's afraid I want something from him." (And I certainly did!) Without saying a word, I gave him the photographs. He seemed very relieved and looked through them with interest. I saw in his expression that he liked them. He gave them back to me with the comment, "They're nice, yes, really very nice." I asked him if he wanted to keep them. He nodded and replied, "Oh, thank you, I like the pictures very much. I'll look at them tonight in peace." With this favorable reaction, I thought it

◁ 12 For the *corrida* in Vallauris which was organized in his honor, Picasso produced the linoleum cut *Toros in Vallauris*.

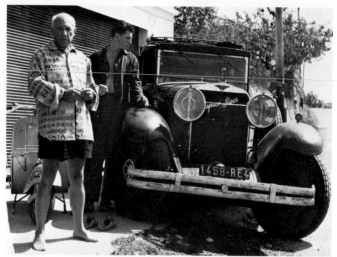

13 Picasso and his son Paul, who usually drove his wonderful, old
Hispano-Suiza cabriolet, at the garage at La Galloise in Vallauris.

was the right moment to ask him if he would allow me to
photograph him at work. He hesitated a bit, "Yes, but . . ."
When I noticed his indecision, I was convinced he would
refuse. But he answered, "Okay, but some other time." That
seemed very promising.

My short career as a photojournalist had already taught me
that patience and perseverance are almost always rewarded.
Thus I often went to Vallauris and waited inconspicuously in
front of La Galloise, unfortunately without success. Picasso
always greeted me amicably, but his standard reply was that
he was too busy and thus had no time for pictures. One day,
though, perhaps impressed by my tenacity and therefore in a
good mood, he came up to me and said, "Come with me."
On that day of course it was not yet clear to me what Picasso's
approval of me might mean. For the moment I was elated at
being able to make an exclusive report and was only anxious

about defective cameras which could spoil this unique opportunity.

So I followed Picasso into the Madoura Pottery and was with him there in his atelier for hours, separated and undisturbed from the rest of the pottery works. I observed him at work. He painted a *corrida* (bullfight) on a plate. He was visibly content to be at work, and I had the impression that he could see the whole *corrida* in his mind and merely had to trace contours and colors onto the white plate. He painted with great dexterity, changed brushes frequently, sketched broad, quickly applied strokes, and added supple, precise lines. Now and then he took a break, lit a new cigarette from a forgotten, smouldering butt, took a couple of deep drags on it,

14 The villa, La Galloise, in Vallauris.

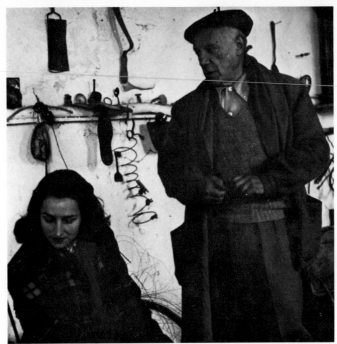

15, 16 Françoise Gilot and Picasso began living together in 1946. She often posed for him, here at the atelier in Vallauris for the *Head of a Woman*, 1951.

and looked deeply engrossed in work as if he wanted to control his work process through analysis and prepare to conclude it.

This first day with Picasso in the Madoura Pottery signaled a highpoint of my activity as a photographer. Thanks to Picasso's encouragements, his persistent interest in my work, and the opportunity to confront him and his work on a regular basis, my entire attitude toward things artistic as well as my own work changed from this day forward. Picasso's elemental understanding of creativity influenced me greatly and helped me to develop an interest in art and artists, nature, and life for the first time.

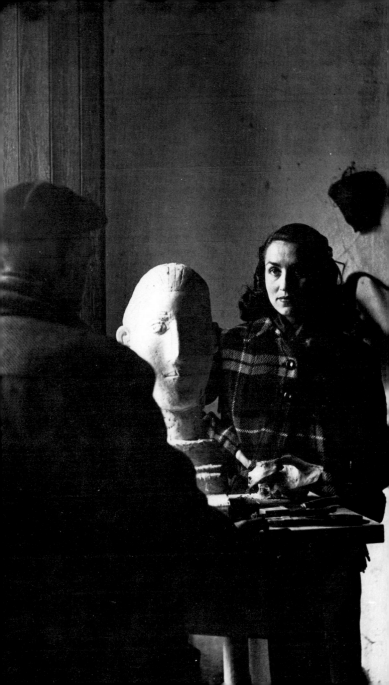

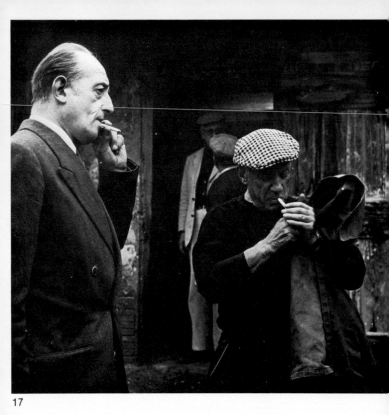

17

Suzanne and Georges Ramié had constructed an atelier for Picasso in their Madoura Pottery. He worked there for years and developed his ideas on ceramics. He laid them out as ceramic designs and could then use and work on them further as printing plates for clay impressions. Suzanne and Georges Ramié had introduced Picasso to pottery, and the craftsmen in their pottery workshop enthusiastically helped Picasso with the development of new techniques. Through Picasso's activities, Vallauris became known as a pottery center.

17 At the Madoura Pottery. On the left Georges Ramié.

18–22 At work in his atelier in the pottery.

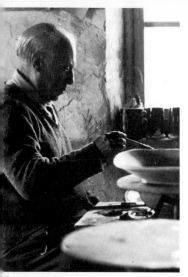

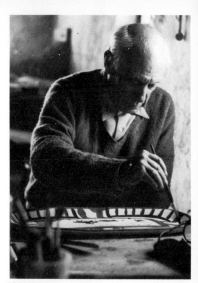

18

19

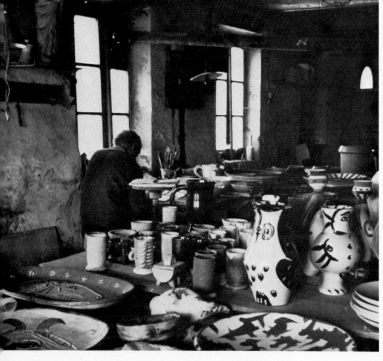

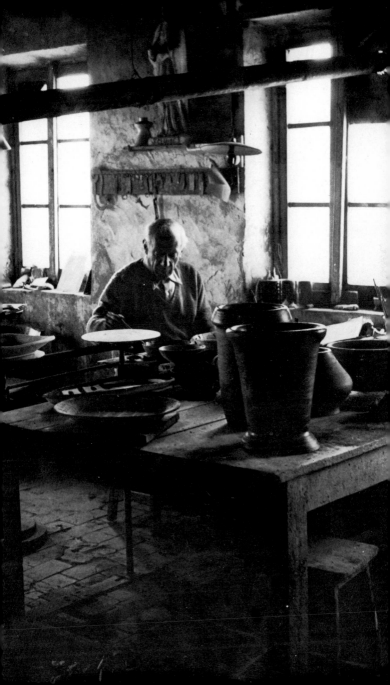

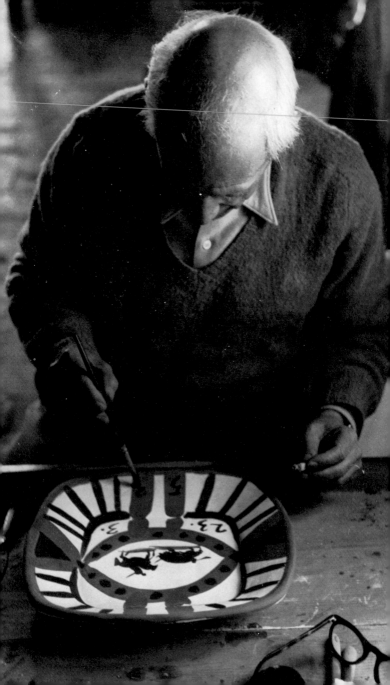

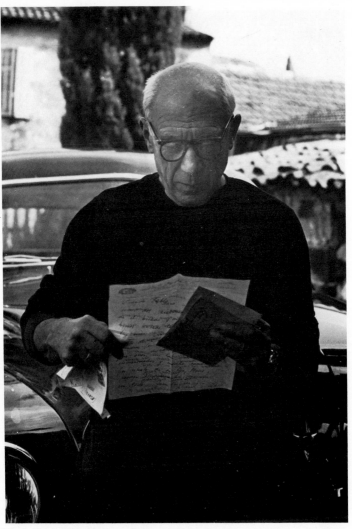

23 In front of the Madoura Pottery in Vallauris.

◁ 22

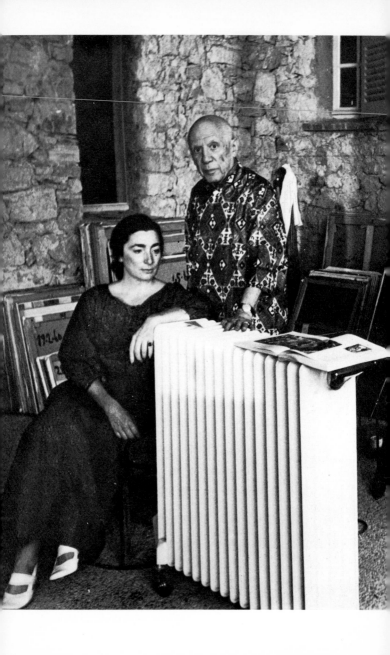

Picasso and Jacqueline

When Picasso's relationship with Françoise Gilot was already quite tense, Picasso met Jacqueline Roque, a cousin of Madame Ramié, the owner of the Madoura Pottery. Jacqueline was 27 at the time and began to work in the studio when Picasso was also there. Since she spoke Spanish rather well, she often conversed with Picasso in his mother tongue. Because of familial difficulties, Picasso was thankful for every friend, and Jacqueline was happy to be a friend to him. Soon her striking, distinctive face, with its dark eyes, began to appear in his paintings.

In the winter of 1953 Françoise Gilot went with their children, Claude and Paloma, to Paris. Picasso, alone in Vallauris, endured a difficult period. Work now seemed to him the only possibility for forgetting his private concerns, and as a kind of self-analysis, he began to work out the theme of "the artist and his model" in around 180 drawings. Françoise and Jacqueline can be identified in these drawings, but also clearly legible are Picasso's interest in and inclination towards women and the problems of love and growing old.

Picasso and Françoise Gilot finally separated, and La Galloise lost all attraction for him. So he decided to leave Vallauris and live with Jacqueline in La Californie in Cannes.

I met Jacqueline during the filming of Henry Clouzot's movie *Le Mystère Picasso*. Picasso was accompanied by Maja, his oldest daughter, and Jacqueline, who was very reserved. She always stayed in the background and only stepped in when Picasso needed something or when he was putting his tools for painting in order in between takes.

Shortly after the completion of the Clouzot movie, I visited Picasso in La Californie. Everything there looked

◁ 24 Jacqueline and Pablo Picasso in Le Mas Notre Dame de Vie.

different from La Galloise. The villa, surrounded by gardens, was situated in the hills in the finest section of Cannes. A very vigilant concierge, who lived in a small house next to the iron garden gate, kept the outside world apart from Picasso's private life. I told her my name and waited until she returned to announce that "Le Maître" would receive me. She opened the heavy gate, and I entered a courtyard expectantly. Picasso stood awaiting me with Jacqueline on his arm at the top of a staircase. Both of them were beaming happily the way lovers do.

In the living room it was easy to see that Picasso's new love had, as always, deeply influenced his work; everywhere there were paintings of Jacqueline. Of course, I asked him if I might photograph his new works, and he generously replied that I could do what I wanted and photograph what I pleased.

I didn't have much more time since Jacqueline came in and cordially but reservedly invited me to dine. She had cleared off Picasso's worktable a bit and set it with dishes Picasso had painted. We had steak with mashed potatoes, cheese, and Picasso's favorite red wine from the Pyrenees. While we were drinking coffee, his doctor arrived, and Picasso "hid" his cigarette from him, laughing loudly. After his examination, he smiled at us slyly and explained that this doctor who had long since forbidden him to smoke (about which Picasso didn't care one wit) had just certified his good health.

Nevertheless, Jacqueline paid a lot of attention to healthy living. She saw to it that he ate regularly and regularly drank his "four ingredient health tea" with honey. Picasso believed in the effect of herbal medicines. Jacqueline saw to it that he went to the doctor on schedule because she hoped that he would be equally official in putting the brakes on her mate's passion for work.

I frequently had the opportunity to observe Picasso and Jacqueline in their daily life and could see that Jacqueline was all-present in every respect. She made sure that he was able to work undisturbed, and that household concerns, calls, or well-intended requests for visits were kept away from him. She took care of his correspondence and made sure that his supply of materials flowed smoothly. That Picasso wished to regard her as a wife, first and foremost, she never forgot, just as she never forgot to maintain comfort in the house. When Picasso came down in the morning, he found everything within the realm of possibility straightened up with fresh flowers set out.

Picasso painted many pictures of Jacqueline. She continually inspired him to paint her. He sometimes recalled one scene or another — that Jacqueline had sat in an old rocking chair, for example. Then he would get a pad, sketch the scene, and frequently produce an oil painting afterwards. When Jacqueline, in order to please him, put on one of the worn items of clothing friends had brought her over the course of time, Picasso would usually begin painting her. During the last twenty years Picasso was happy to have Jacqueline around. Painting took up all of his time, and Jacqueline knew that his work was the true center of his life. Therefore, she did everything in her power to support him, often with no regard for her own interests and health. Picasso was thankful for this devotion and married her quietly at the beginning of 1958 in Vallauris.

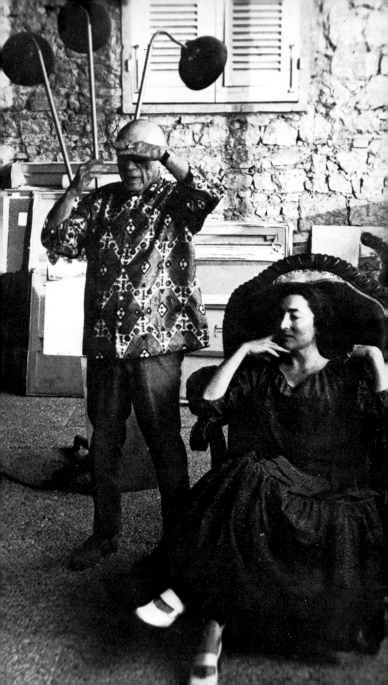

25 Looking at new paintings in the atelier at Le Mas Notre Dame de Vie.

26 The Château de Vauvenargues from the 14th century.
When the property below the villa La Californie, which Picasso had bought at an unreasonable price, was purchased by a real estate agent, Picasso looked around for a new place of residence. He found Vauvenargues, a château in a beautiful location in the Provence, and was thrilled with the edifice. He immediately read up on the Marquis Luc Clapiers de Vauvenargues, the philosopher and friend of Voltaire, and looked forward to the move. He then had the right to the title Marquis de Vauvenargues, since it went along with ownership of the château. This pleased Picasso tremendously; nevertheless, after a few months' time he came to the conclusion that the solitary country life was too taxing, particularly in winter, and he decided to return to La Californie. Construction was well under-way on the property he had sold. He no longer wanted to stay at La Californie, and bought a roomy house named after a nearby church, Le Mas Notre Dame de Vie, which was shaded by cypress trees. It was situated on a hill near Mougins, not far from Cannes. ▷

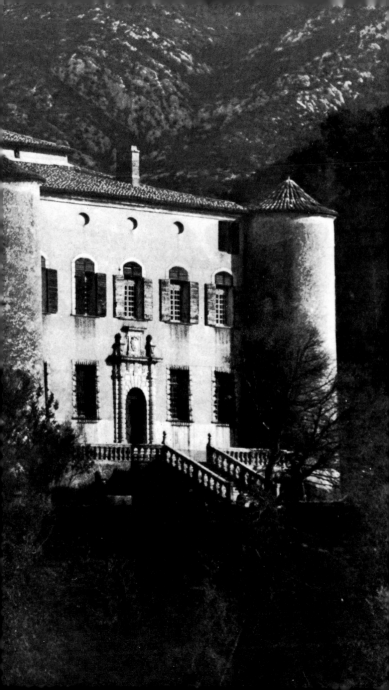

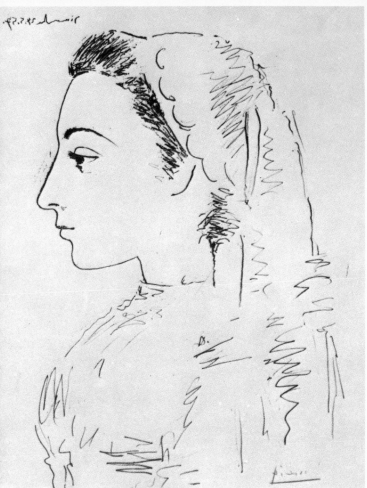

28 *Jacqueline in Profile.* Lithograph, 1957.

27 The villa La Californie seen from the garden.

29 La Californie was a residence, storehouse, atelier, and showplace for Picasso, depending on his needs. He removed the pompous interior decorations, filled the walls with pictures, masks, souvenirs, tapestries, and hats, and stuffed the rooms with paintings, tables, and other furniture in order to live there according to his own taste. Thus, his worktable was also the table at which he ate, gathered with his friends, read, talked, or watched television. ▷

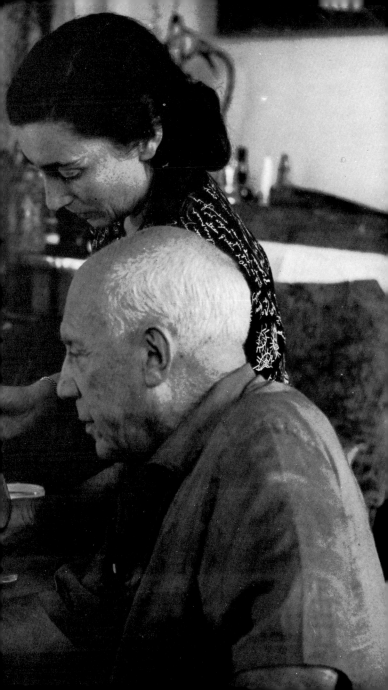

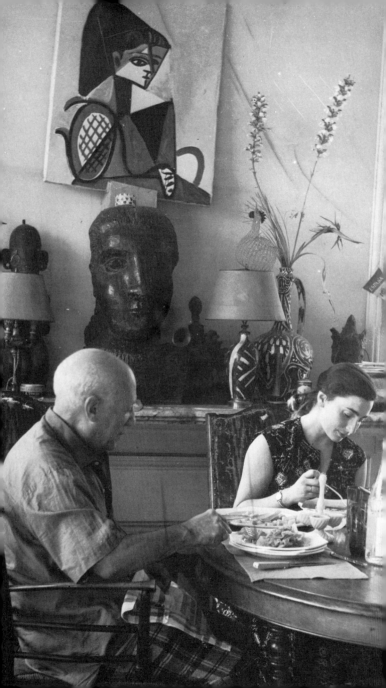

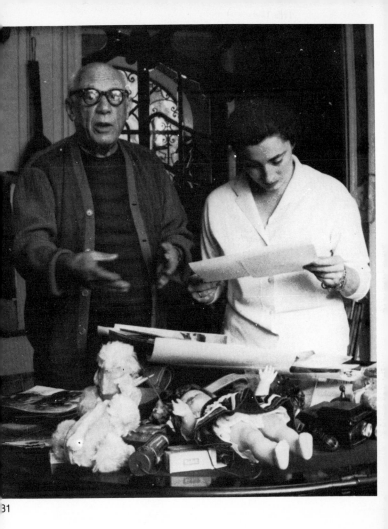

31

30–33 Jacqueline took care of everything in the house, enabling him to work undisturbed, and provided Picasso with a pleasant home atmosphere. He valued her presence highly, and loved to sit with her in the living room drinking tea, talking, discussing his new works, and receiving guests.

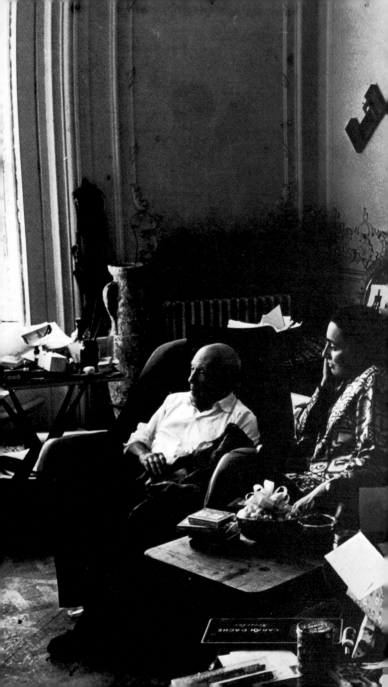

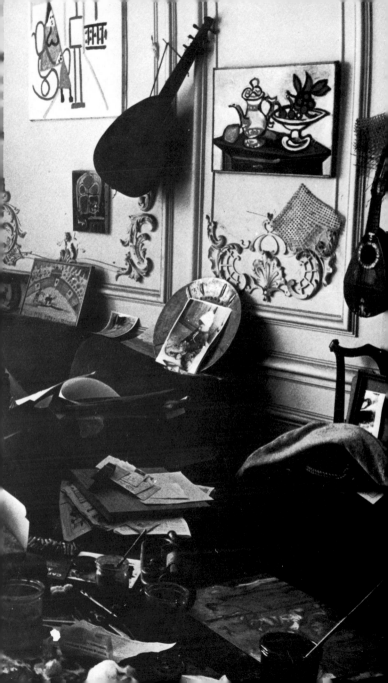

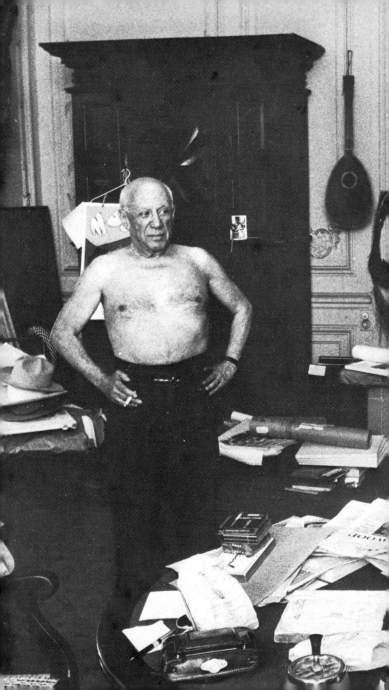

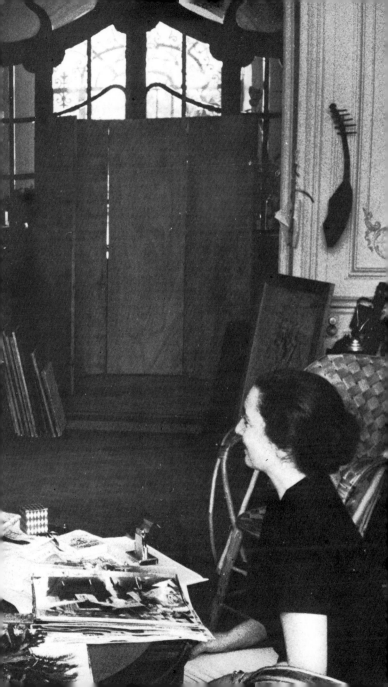

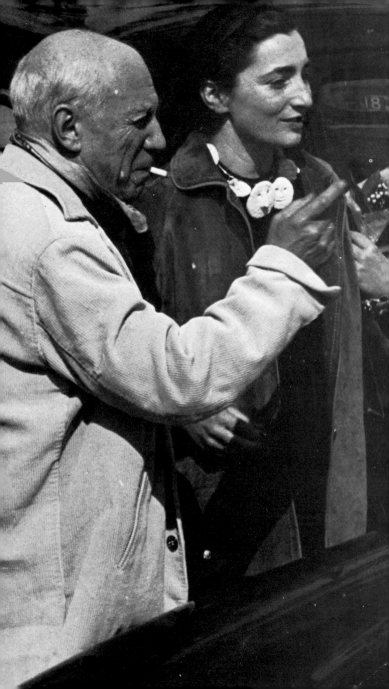

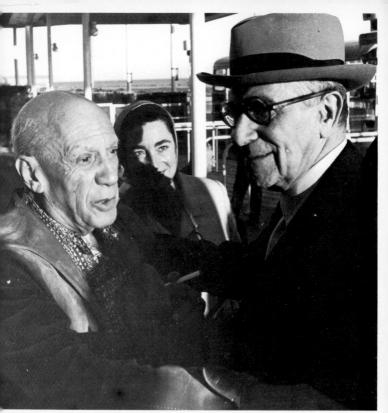

5 Saying good-bye to Dr. Gutmans at Nice Airport.

Dr. Gutman, an old friend, urgently advised Picasso during a 1964 visit to have a gall bladder operation. Picasso heeded his friend's advice and went to Paris for the surgery amid great secrecy. It went well. He returned home relieved and in the best of spirits.

◁

34 Picasso didn't enjoy leaving his residence (the Château de Vauvenargues was already basically too far away for him). When he did go away, however, Jacqueline accompanied her spouse and then took care of everything in her usual manner.

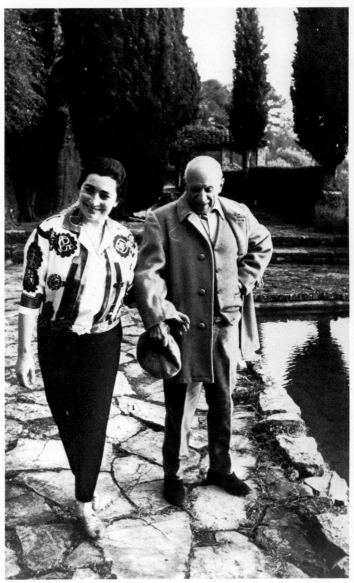

36 The day he returned from Paris in the garden of Le Mas Notre Dame de Vie.

Picasso and His Ateliers

The atelier was Picasso's oasis. He was content there and loved to look in solitude at one or another of the many objects his friends had given to him as gifts. After contemplating or doing what seemed like nothing for a short time, he would begin to work.

He was an active man who didn't think much of sitting around "waiting for ideas." He preferred to get a canvas and begin working. When I had the opportunity to observe him painting, I took particular notice of his intense facial expressions and his deep engrossment. He forgot about his surroundings completely. It was quiet in the room; the only thing to be heard was the squeaking sound of his charcoal pencil or the dull scratching of his brush on the canvas.

Picasso worked uninterruptedly to realize his conceptions; he did not accept simple solutions and compromises. With each challenge that he did not overcome immediately he doubled his efforts and worked feverishly, completing drawing after drawing to come that much closer to his conception. He evaluated his work, throwing it away or keeping it as *une trouvaille.* He once explained his aggressive manner of painting thus: "When you begin a painting, often the most beautiful things appear. And it is precisely this that you have to protect yourself from; you have to destroy the picture, always make it new. Because when you've destroyed one of these 'beautiful finds' you haven't really ruined anything; you only work it over, make it denser, leaving what is substantial. A good result is the sum of all the discarded finds."

Picasso didn't take his great gift for granted. He always continued working, spurred on by self-made tasks. He planned, discovered, and was disappointed by failures, but in

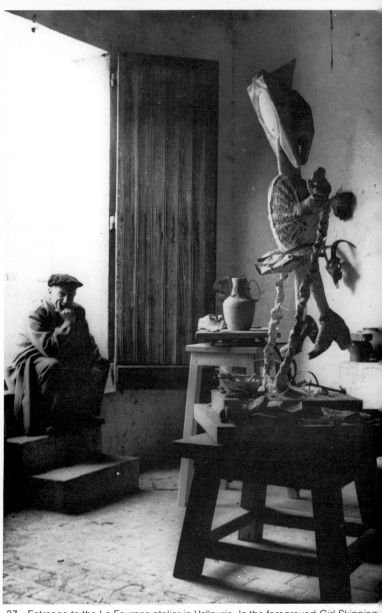

37 Entrance to the La Fournas atelier in Vallauris. In the foreground *Girl Skipping Rope*, 1950, an assemblage made from a wire frame, wicker basket, cake tin, ceramic forms, and plaster.

the end was probably always satisfied with the results he achieved through single-minded searching, even though he once remarked: "A picture or drawing is basically never finished. I can always still imagine changes that would perhaps add a color that would further accentuate something specific or suddenly make the original work merely the point of departure for something completely new."

During the filming of the Clouzot movie I found substantiation for these statements. For the film he had started a painting which portrayed life on the beach at La Garoupe, his favorite beach near Antibes. Enthusiastically, he began to fill the surface with a geometrical, visual structure, then he added people — swimmers, people taking a walk — put in houses, trees, boats, a radiant sun; the beach began to come to life. He painted a girl and then a young man. They were small at first, grew larger and larger, and for a moment were a pair of lovers. Picasso changed things

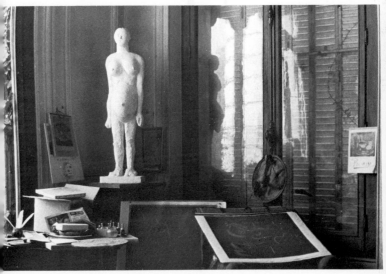

38–39 A corner of the living room at La Californie with the plaster cast of *Pregnant Woman*, 1950.

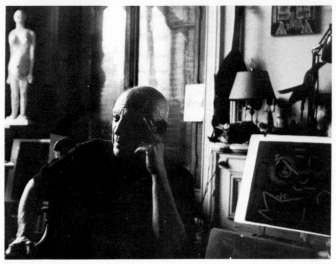

39

incessantly. The sun disappeared, stars glowed. Picasso glued pieces of paper onto the canvas and tried out new ideas. He tore them off again, finally turned to Clouzot and grumbled, "This won't amount to anything. Nothing at all. This isn't what I want. I don't like it at all. I'll try it again. Then people will at least see that it isn't so easy. I'll start over." He reached for the bottle of turpentine and wiped off a good portion of the picture with a few broad brushstrokes. He began anew, and after a few hours he set the brush aside exhausted. He had decided he'd gone as far with the painting as he wanted to now. Later he got a new canvas, sketched another structure, put in figures with black paint, and had created the quintessence of the previous painting in an astonishingly short time. It almost seemed as if the hard work of the first painting had been necessary to enable him to paint his mental picture in a few short minutes.

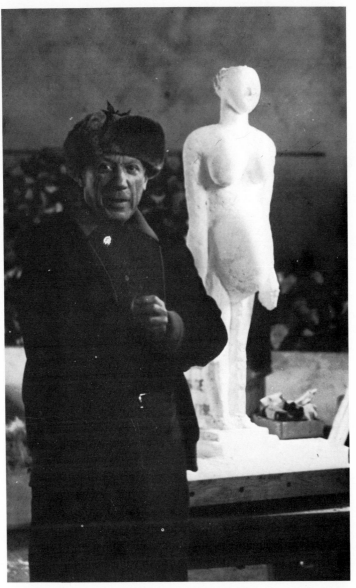

40 Picasso in the La Fournas atelier in Vallauris where he had sculpted the
Pregnant Woman.

41 View at the entrance to one of the atelier rooms.

Often a change in mood or outside influences were all that he needed to complete work on a picture. Thus, he only signed paintings when they were leaving the house for an exhibition or a buyer.

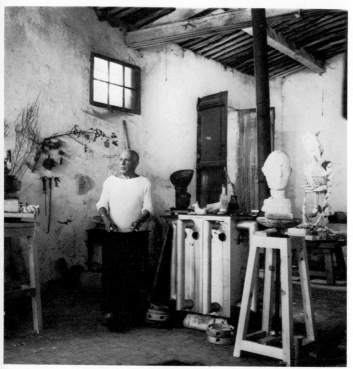

42 View of the entrance to the atelier.

When Picasso constructed his atelier in La Fournas, a former perfume factory, there were mountains of old iron and machine parts everywhere. Picasso added his own *objets trouvés* to it because this pile of bicycle parts, rusty nails, pots, old pipes, chains, and screws was a treasure trove for him. Out of these materials he constructed such well-known sculptures as *Goat,* 1950 (out of a palm leaf, flower pots, a wicker basket, metal scraps, and plaster), *Goat Skull with Bottle,* 1951 (out of a bicycle handlebar, nails, metal, and plaster), and *Baboon and Young,* 1952 (out of plaster, metal, ceramics, and two toy cars). Picasso loved to work in this atmosphere. The materials lying at his fingertips also inspired his series of assemblage sculptures.

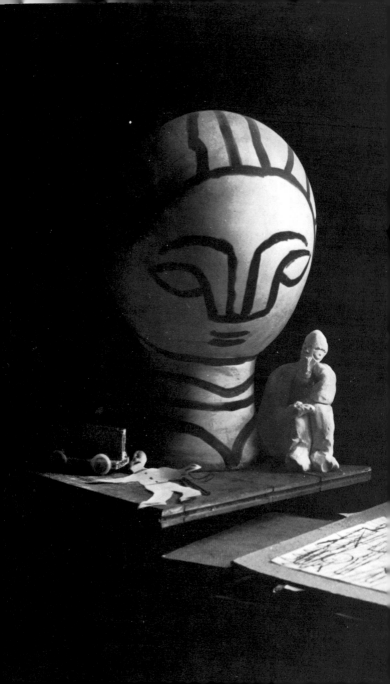

43 In a corner of the living room at La Californie. Picasso's need to collect and display everything in groups, a little wooden toy bus he painted for the children with a ceramic head, a small plaster figure, and a small Roman oil lamp.

44–50 Life at La Californie centered around the living room. Picasso favored its high, brightly lit spaces. He spent a lot of time there whether opening a crate from which the model of a carafe of Morano glass he had designed had come, or comparing the print in a book with his original and becoming fascinated with the variations. Over the years he collected vast quantities of presents, *objets trouvés,* souvenirs, paintings, designs, and sculptures. He filled the walls with hangings and scattered everything in all the rooms. He spread out in other rooms to paint and thus enlarged his atelier again and again to create more room. He also wanted to see his own paintings and arranged examples from every period into a kind of private exhibition. ▷

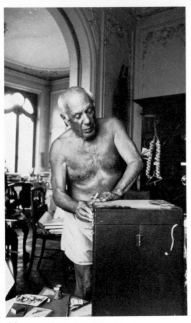

44

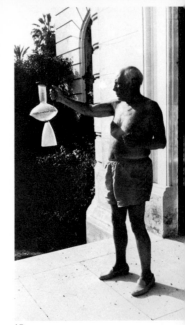

45

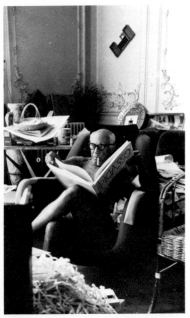

46

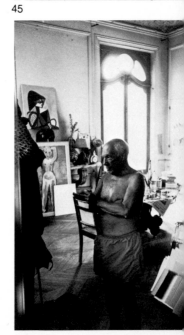

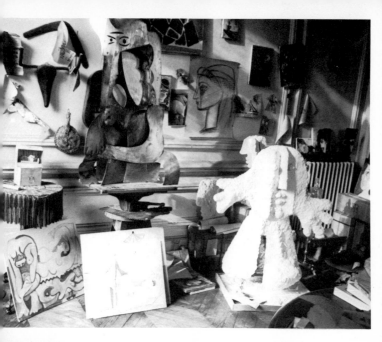

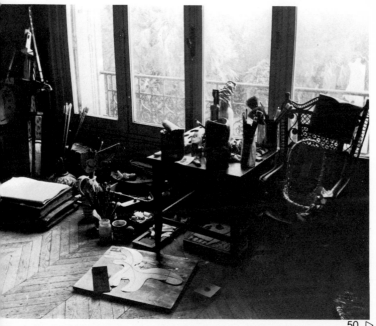

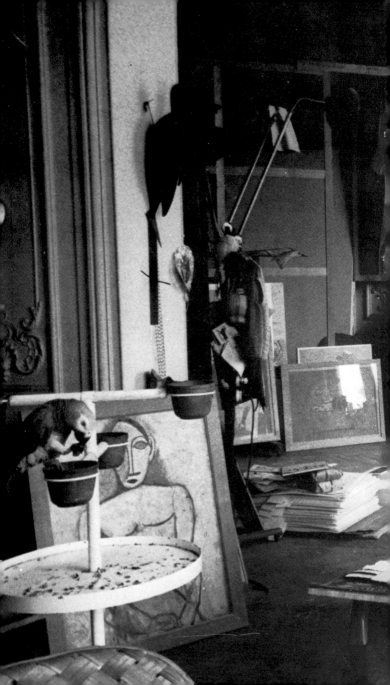

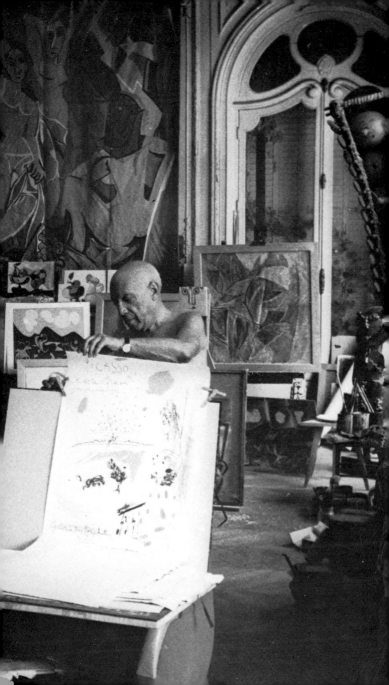

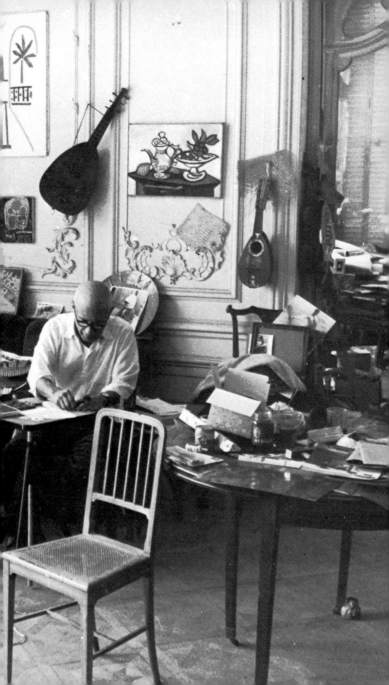

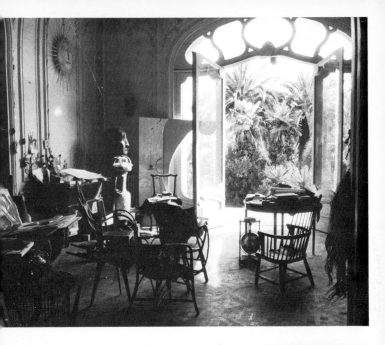

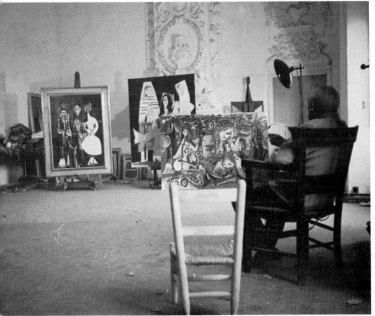

51 Picasso often sat on the living room sofa and drew. Because all the places to sit were usually piled with things, Picasso used to clear this corner of the sofa off in order to work.

52 View past the sitting area into the palm garden at La Californie. This is where he usually sat with guests.

53 The *grand salon,* used as an atelier, in the Château de Vauvenargues.

54 Le Mas Notre Dame de Vie in Mougins.

55 Kabul on the terrace in front of the entrance to Le Mas Notre Dame de Vie. Because this house also quickly became too small, Picasso had a room built onto the terrace for an atelier.

54 55

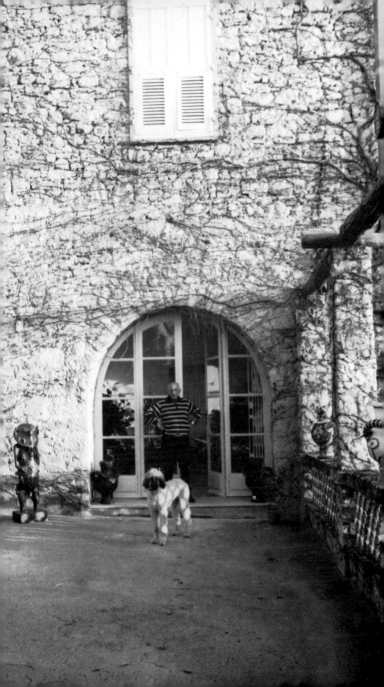

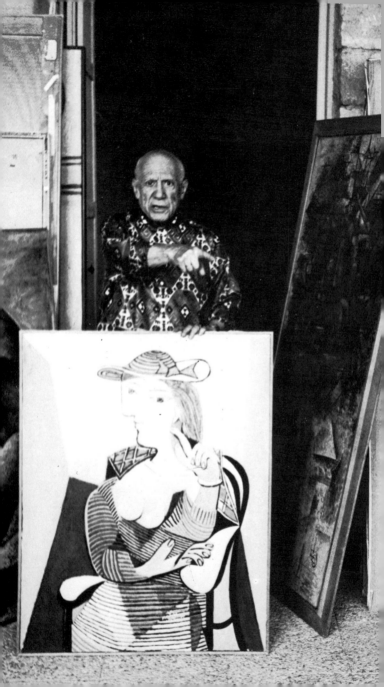

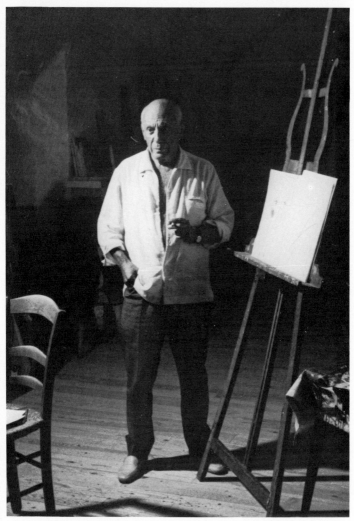

57–58 Even when Picasso was over eighty years old, he didn't give up his old habit of working at night. He loved complete silence and solitude and was thus assured of not being disturbed.

◁ 56 Picasso with the Portrait of *Marie-Therèse Walter*. 58 ▷

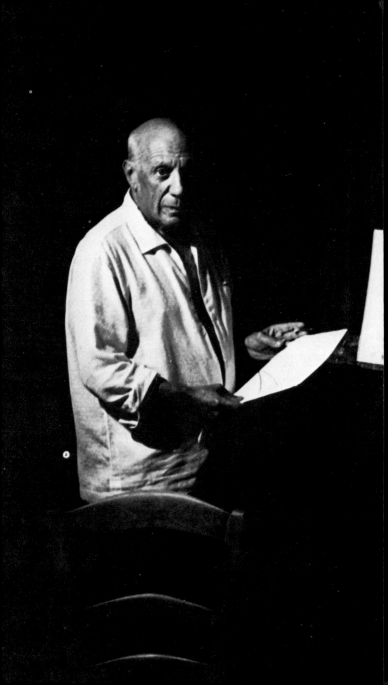

59–60 Picasso had great respect for technology. The cinemascope camera Georges-Henry Clouzot used for his 1955 film *Le Mystère Picasso* sparked his interest. Clouzot had suggested he make a film that would show him at work. Picasso enthusiastically agreed and had a frame constructed on which he could stretch a transluscent piece of paper. He drew on one side, and the camera filmed the drawing being born from the other side. Picasso was very pleased with the work and the results. In order to film individual stages of the painting process, Picasso sometimes had to interrupt his work for brief periods. This confused and irritated him. Besides this, there was the intense summer heat of the Riviera which was intensified to the unbearable point by the floodlights in the Nice studio. This caused the 74-year-old to have a mild heart attack. He rested for a few days but returned again and completed the film.

59 60 ▷

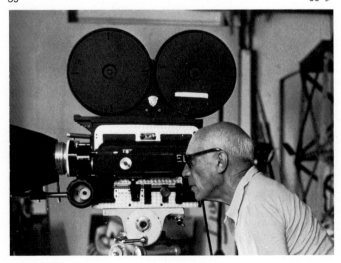

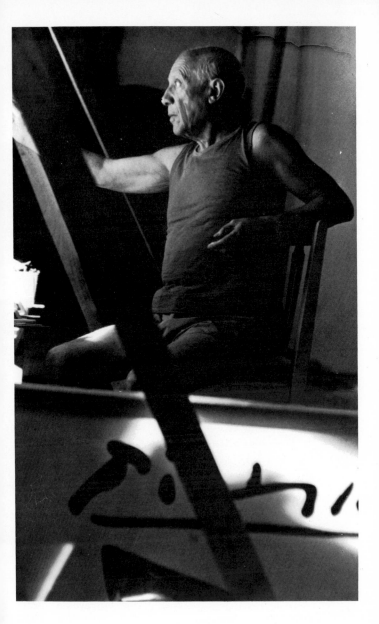

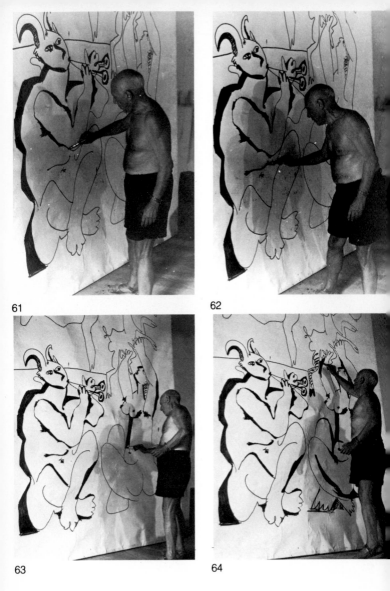

61

62

63

64

61-65 On drawing paper Picasso drew one of his favorite themes, a
bucolic pastoral scene, which was to serve as the background for
Clouzot's film.

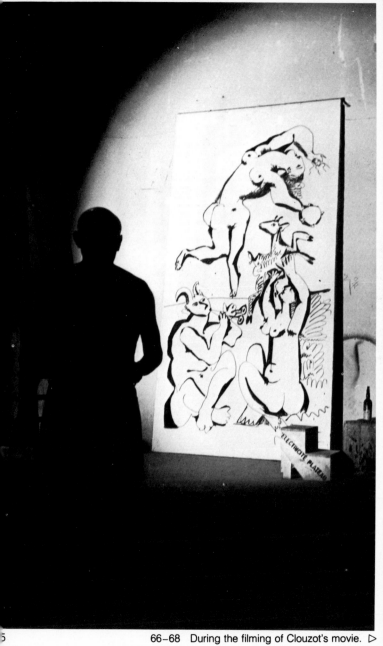

66–68 During the filming of Clouzot's movie. ▷

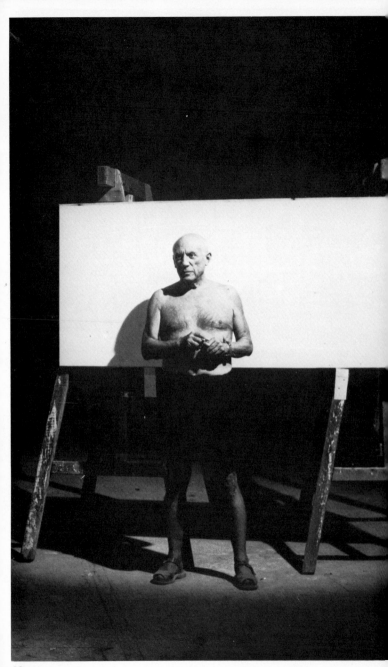

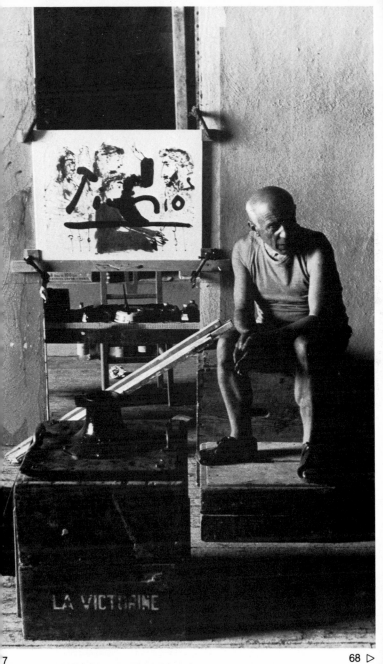

68 ▷

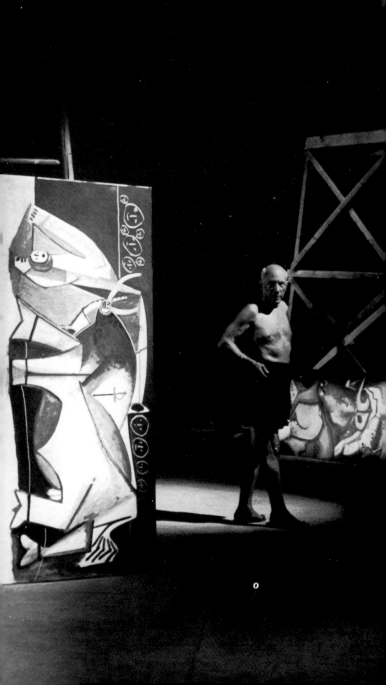

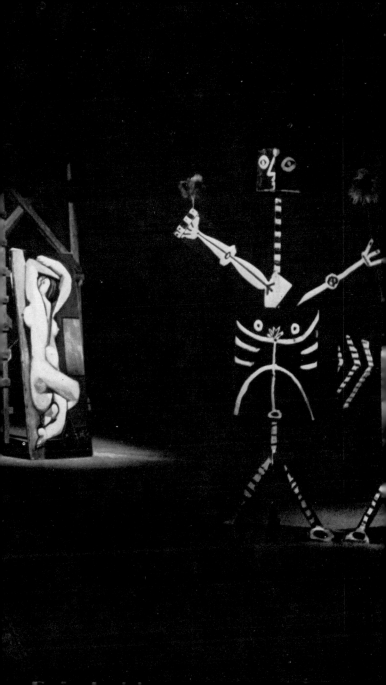

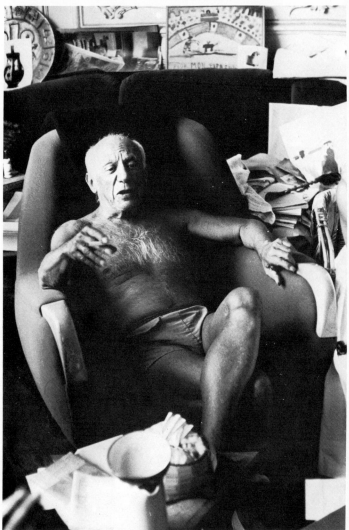

69–72 In La Californie where, during the conversation, Picasso quickly finished off a drawing for a charitable society so that the visitor could take it with him.

Friends and Visitors

Many people wanted to visit Picasso, but he only allowed a small circle of friends in his atelier. Letters and telegrams asking permission to visit he left unanswered, for he loved to read them but not to answer them. Speaking to him by telephone was also practically impossible. To be sure, Picasso had nothing against meeting people; he was very fond of conversation and was himself a great conversationalist. But he did fear losing valuable work time by doing so. There were intense periods when he would work day and night on a series of pictures or try to grasp onto a new theme. During these times he was unpredictable, unusually moody, and didn't want to see anybody — not even his closest friends. If he had completed a successful period of work, then visitors were welcome and he greeted them warmly.

I knew this. Thus I called a few times, and he finally received even me. Once I was in his house, everything was fine, and Picasso embraced me in greeting. When he apologetically said, "You know I had work to do," I accepted this apology laughing (I had finally interrupted his work) and made it clear that it hadn't bothered me at all. He felt that his refusal hadn't been particularly nice and felt somewhat guilty. All the same he still expected good friends to understand this. A few friends, though, even some who had been good friends for many years did not understand it and were bitterly disappointed when Picasso broke off the relationship.

Picasso observed what went on around him with a lively interest. He was very interested in people and events, and because he traveled only infrequently, he was very glad to keep in contact with everything that interested him through his many visitors.

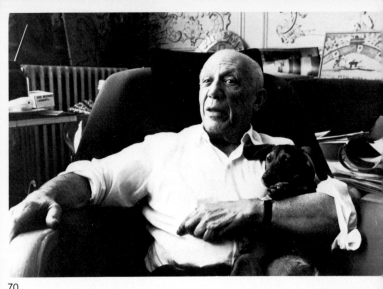

70

A visit with Picasso was an adventure; you had to be prepared for anything. He loved the contrast between the trivial and the highbrow. Conversations never went in the expected direction. He usually surprised his visitors with his sound knowledge, his wealth of ideas, and his gift for memory. He was very funny and capable of enthusiasm. New visitors were often surprised by his many talents.

When someone came with work, Picasso interrupted the conversation to attend to his guest. When, for example, a printer arrived to present for his approval a lithograph or color print that had been difficult to reproduce, Picasso immediately engaged him in a lengthy technical discussion. He liked that; he valued technical knowledge highly.

Frequently, visitors came who were politically active and asked Picasso to support them in their work. Or they asked him to sign a manifesto against political oppression and to

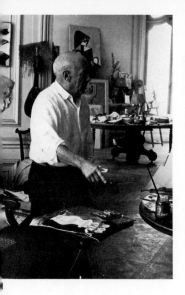
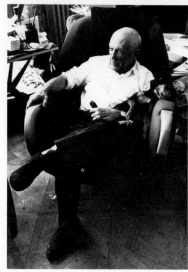

72

stand up for a country threatened by aggression. Picasso listened with great sympathy and supported them when he was convinced of their sincerity, even when he couldn't examine everything closely.

As different as their reasons for visiting Picasso might have been, all of his guests usually wanted to see his most recent works. He in turn always showed them willingly and would organize a small, impromptu exhibition of them in his atelier.

If he became restless later on, that meant to everyone who knew him that it was time to go. Almost no visitor left Picasso without feeling he had been with a man who radiated a truly wonderful personality and a tremendous attraction.

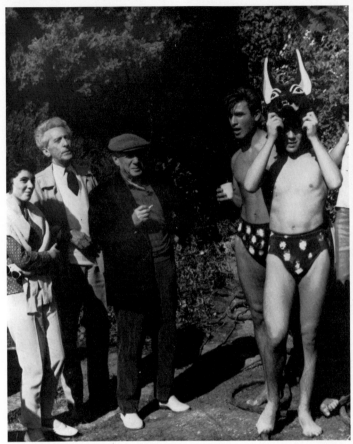

73 Jean Cocteau, poet and filmmaker, had been a friend of Picasso's since
 1916. Back then he had arranged for Picasso's commission to do the
 sets for Diaghliev's *Ballets Russes*. Cocteau and Picasso met regularly
 on the Côte d'Azur. Picasso also visited Cocteau at the villa Santo
 Sospiro when the latter was filming *Le Testament d'Orphée*. Cocteau
 took advantage of the opportunity and had Picasso appear in a short
 sequence.

74 Flirting with charm, Picasso poses with Mme Weisweiler in the garden of
 her villa, Santo Sospiro.

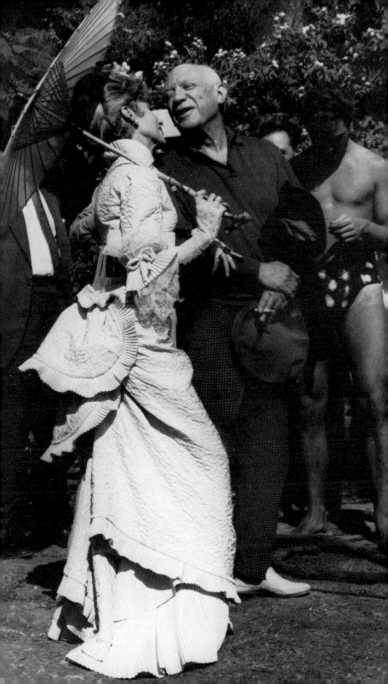

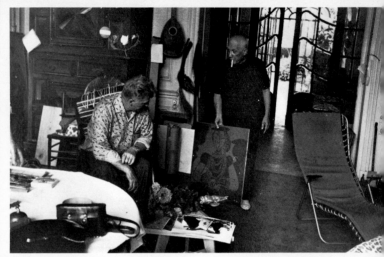

75

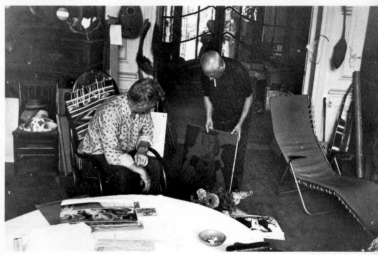

76

75–78 Picasso paid close attention to reactions to his work and valued criticism
from friends and colleagues. One of his painter friends was Edouard
Pignon. In 1936 Pignon and a few other painters had a dispute with the
organizers of an exhibition over the hanging of their pictures. Picasso
stepped in, and after a short discussion, saw to it that the pictures of the as
yet unknown artist were hung next to those of Braque, Leger, and himself

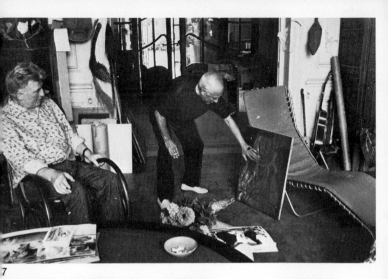

7

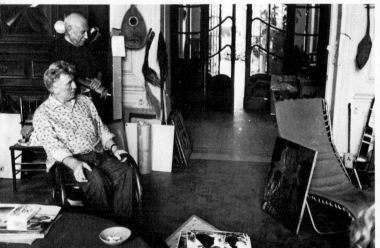

8

He kept up with Pignon after that. He was one of the few who, because of his intensity and his enthusiasm, could break through Picasso's aversion to talking about art. He often even succeeded in discussing and analyzing Picasso's own work with him.

Here Picasso shows him the original linoleum cut which he had executed only shortly beforehand on the inspiration of a picture by Cranach.

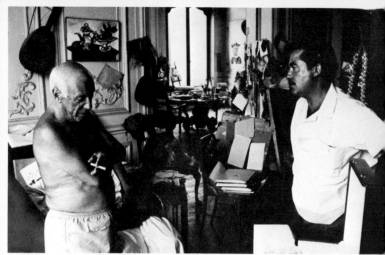

79

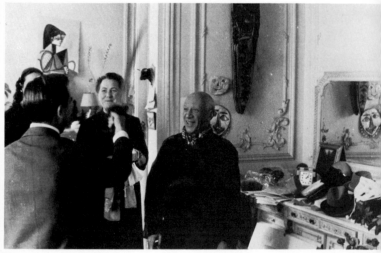

80

79 Picasso liked visitors from Spain, as here with the painter Antonio Clavé. Then he could speak Spanish once again and get accurate information about Spain and the situation there.

80 A group of friends had showed up to celebrate Picasso's birthday, among them Señora Gili, the wife of a Spanish publisher, and his sister Lola's son, the painter Javier Vilato.

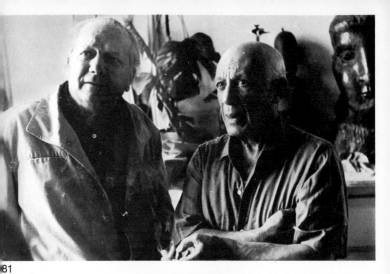

81

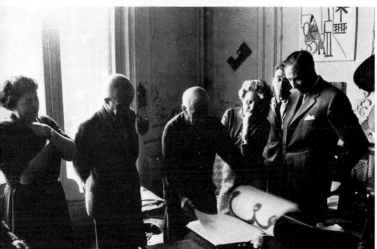

2

81 The Italian painter Alberto Magnelli at La Californie.

82 Picasso leafs through the special edition of a book of poems by Pierre Reverdy to which he contributed the illustrations. Looking on from the left are: Mme Weill, the writer Michel Leiris, Louise Leiris, both gallery owners in Paris, the book's printer, and Andre Weill, who had published some rare editions of Picasso.

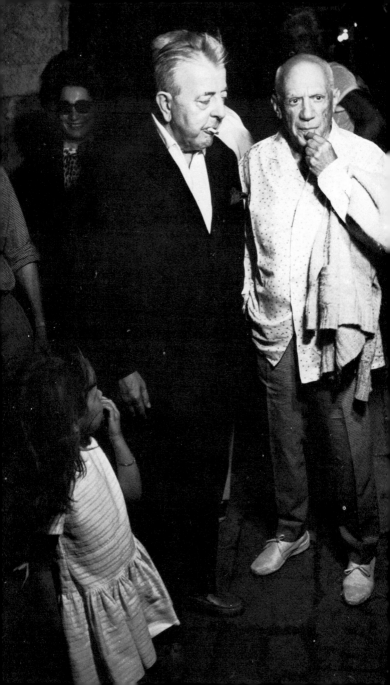

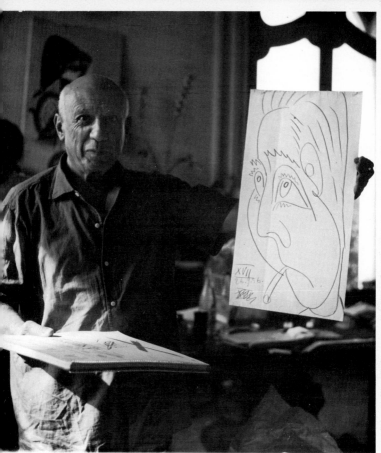

4 Picasso with the drawing *Jacques Prévert,* 9/26/56.

he poet Jacques Prévert lived not far from Picasso on the Côte d'Azur. Because
ey were neighbors, they saw each other often. Picasso was amazed that Prévert
lways had a cigarette between his lips; when the latter asked him to draw his
ortrait, he couldn't resist drawing him as he always saw him — with a cigarette in
is mouth.

3 Prévert and Picasso at an exhibition of the poet's collages.

Daniel-Henry Kahnweiler, Picasso's friend since 1907. He was also his dealer and frequently visited Picasso in Paris. Picasso valued the presence of this old friend highly.

85 *D. H. Kahnweiler,* 1957, lithograph.

86 Picasso and Kahnweiler follow Jacqueline to Picasso's 75th birthday party.

87 Picasso examines with fascination the barometer clock Kahnweiler brought him as a birthday present. On the right, the Spanish publisher Gustavo Gili.

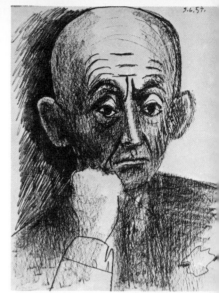

85

86

87

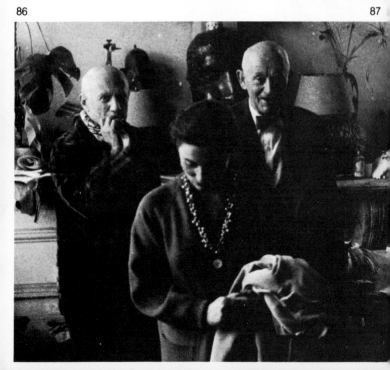

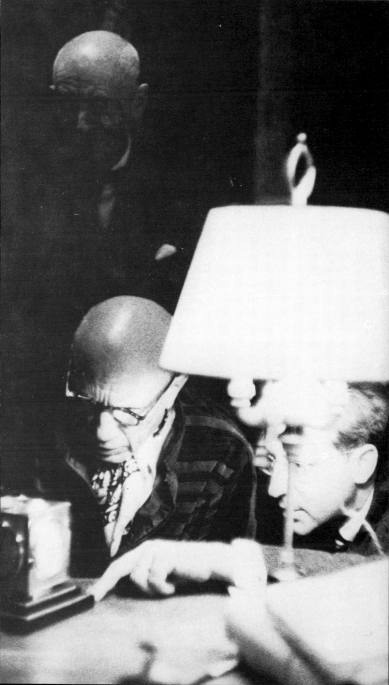

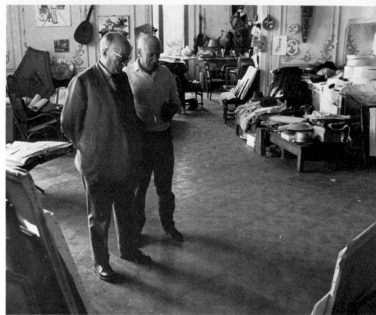

88

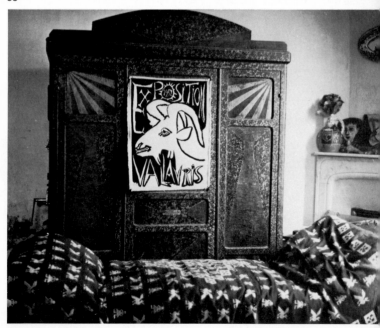

89

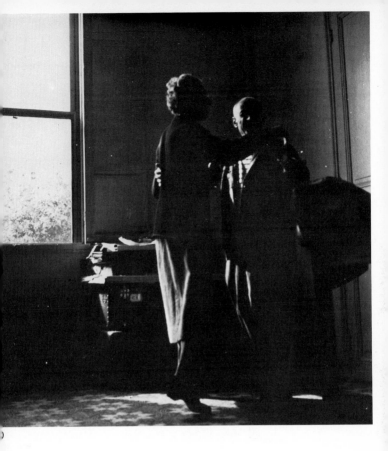

88 Jaime Sabartés and Picasso critically examine a portrait of Jacqueline. Picasso valued Sabartés' opinion highly. They met in 1899 as members of a group of artists which regularly met in the *Els 4 Gats,* a cafe in Barcelona. They remained friends ever since.

9–90 Picasso had bought an old hurdy-gurdy in Vallauris. If he wanted to especially please a guest, he turned the handle forcefully. It played an old waltz, somewhat shakily. One day he gleefully demonstrated it to Mme. Hugué, Manolo's wife, his old friends from the days in Montmartre at the Bateau Lavoir. When I saw Picasso moving in time to the music, I asked him if he could dance. He quickly grabbed Mme. Hugué around the waist and twirled elegantly about the room.

91 Picasso liked to invite people to local cafés. Though the name Picasso did wonders, Jacqueline had difficulties steering her husband's quick decisions into realizable directions, because they were mostly visitors who had to be put up in a restaurant-hotel. Here Picasso is with the art dealer Louise Leiris and his son Paul. He ate very moderately but always made sure that his guests ate a lot and well, and that there was always champagne on hand. The latter he saw to himself, being a lover of champagne.

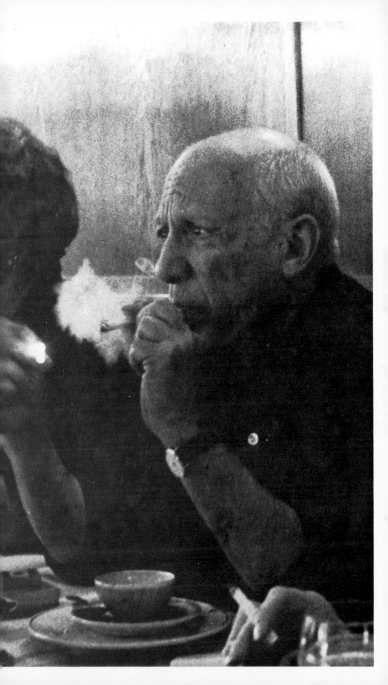

Picasso and his Children

Children and their world always interested Picasso, even as a young man. The themes "mother and child" and "circus children" preoccupied him particularly during his blue and rose periods. When Olga Koklova bore Picasso's first son, Paul, in 1921, he whiled away blissful hours observing mother and child. Like a reporter, he preserved his children's growing up in drawings and pictures. This was also true for his daughter Maja, whom Marie-Thérèse Walter bore him in 1935. When he was able to take care of his daughter, he was thrilled to do so and even set his work aside to that purpose, which was indeed unusual for him.

In 1947 Claude was born and in 1949 Paloma. They, too, were a source of inspiration for him. During the period that Picasso lived with Françoise Gilot and his children in La Galloise, he spent a lot of time with them and often painted them even as they slept. I had many opportunities to observe the children's affection for and inclination toward their father. Picasso played with them and built dolls and wooden playthings for them which he put together from pieces of wood he found and then painted. To amuse them he cut out paper silhouettes of people and animals, pasted them over, and gave them enchanting or comical facial expressions. Some of these toys still exist, but because they were playthings, most of them have been destroyed.

Very early on Picasso took his children to the sea and taught them how to swim. He enjoyed being at the seashore, and because he loved to lay about there, he forgot about his work for a short time.

Picasso himself looked at things with a child's eyes, and he envied children their lack of inhibitions. They steadfastly

92 Picasso with his youngest daughter, Paloma. ▷

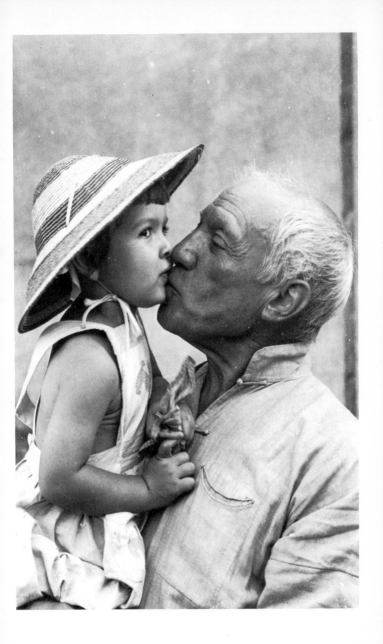

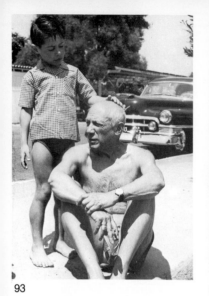

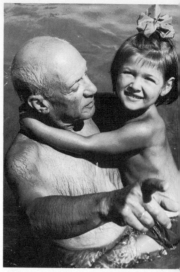

93 94

revealed new things to him and through their eyes enabled him to see the world and everything that happened in it differently. With their help, it became clear to him that a child's world is made up of a mixture of fantasy and reality, and since he lived with them and took them seriously, his interest in human existence intensified. "Il faut beaucoup de temps pour rester jeune," he has said and probably meant that it took him almost until he was sixty years old to still be young with his children. He loved to paint with them. Mostly, though, he limited himself to watching them, admiring their inventiveness, and delighting in the results of their unspoiled spontaneity. When Claude and Paloma were not in Vallauris, instead of writing to them, he would send them colorful stories of the week's events in pictures.

Of course, Picasso didn't fail to notice his children's less pleasant character traits either, and there are drawings from this period which preserve these qualities exactly. The

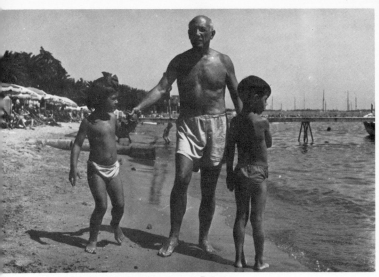

93-95 With his children, Claude and Paloma.

children had complete freedom to play wherever they wanted. Picasso, who had strictly forbidden adults to disturb anything in the house, allowed children and animals to do anything. Nevertheless, visitors often thought it scandalous that the children played hide and seek behind irreplaceable paintings from the rose, blue or cubistic periods, or that they ran after the dogs between rows of work on display.

As Picasso's children grew up, they, like all children, lost their uninhibited manner, their childlike innocence, and their dependency on their parents. Picasso was no longer so bound by them. For various reasons, the relationship between Picasso and his children was not good during his later years. There were considerable differences of opinion about Françoise Gilot's book *Life with Picasso*. This resulted in Claude and Paloma not visiting their father after 1965. Misunderstandings on both sides had separated them permanently.

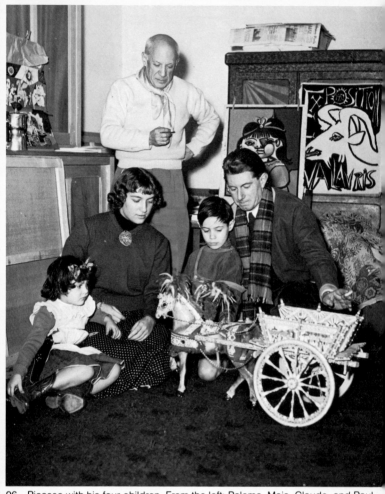

96 Picasso with his four children. From the left: Paloma, Maja, Claude, and Paul.

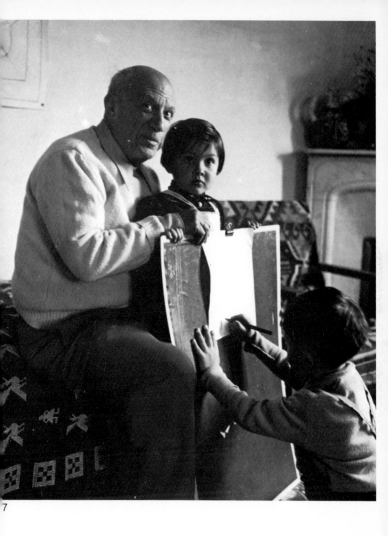

7

7–101 Picasso often sat with his children so that they could all draw at the same time. Picasso restrained himself when he did, never actually interfering but encouraging the children only through praise and explanations — and his own participation.

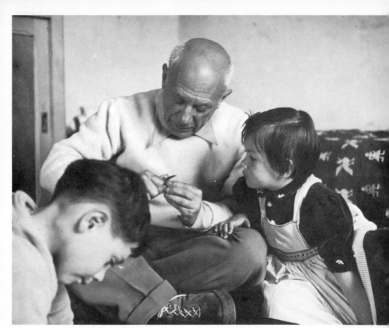

98

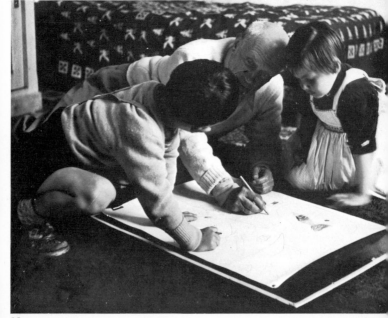

99

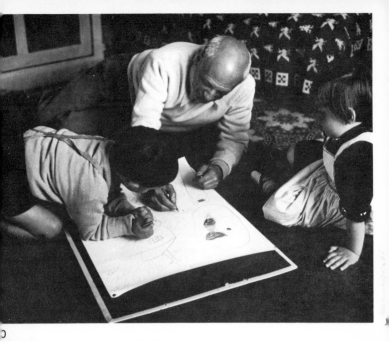

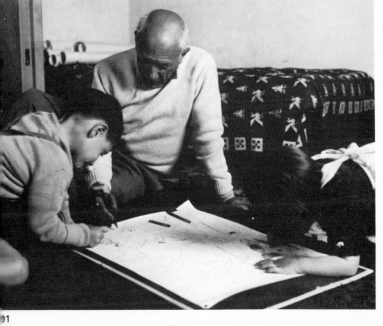

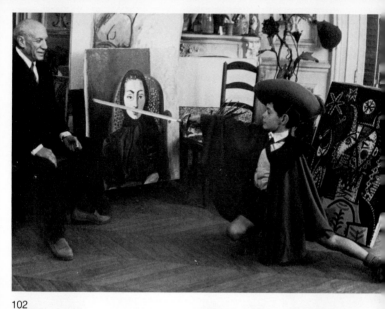

102

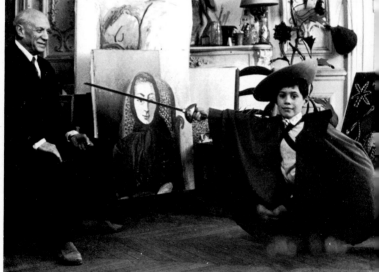

103

102–105 Claude as a little Spanish Grande.

106–108 With Claude and Paloma in La Californie.

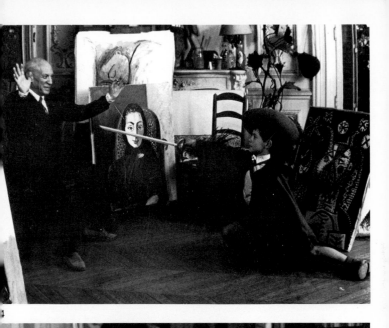

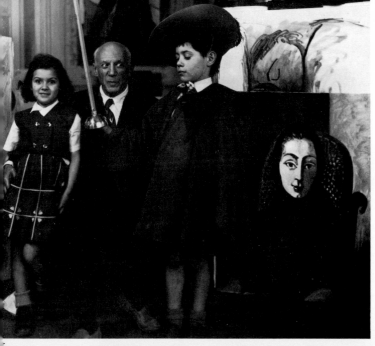

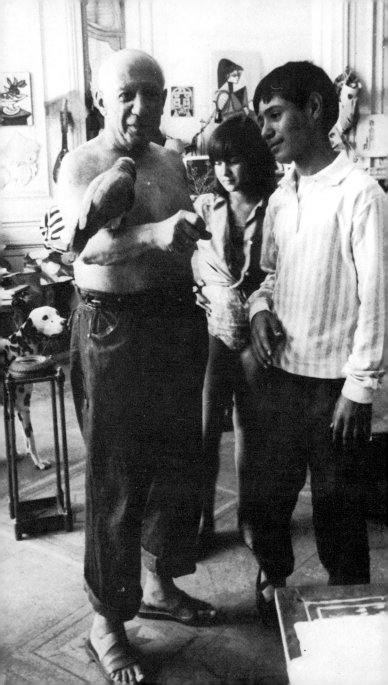

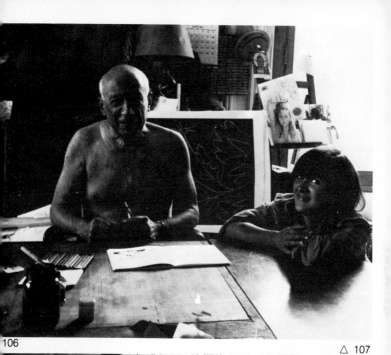

106

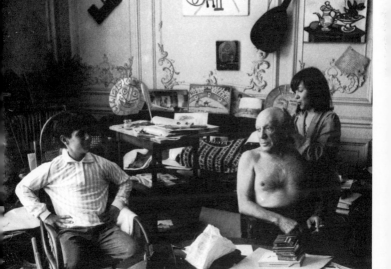

Toros y Toreros

Every year major bullfights take place in southern France, in Arles, Nîmes, and Frejus, where there are still bullrings. Picasso, an aficionado since childhood (he painted one of his earliest pictures, a *picador,* at the age of eight), often participated in the *corridas.* He loved the bullfight. But about a week before the event he would become agitated and ask himself if he should go at all or continue working. This indecision kept the family on pins and needles to the very last minute. His son Paul would buy tickets in advance to make sure they could go, because it was impossible, even for Picasso, to get tickets anywhere on the day of the bullfight. After he had finally made up his mind, he got up very early and drove to the arena via the quickest route. Sometimes, when he had already decided beforehand to go to the *corrida,* he would travel through Provence the day before and stay overnight.

Traveling with Picasso was indeed confusing and exciting. I drove with him to Arles and Nîmes a couple of times. The drive became a ritual; only after we had stopped for coffee in Aix-en-Provence could we continue the journey, and that was on dusty, hot country roads all the way to the arena itself, which he would enter shortly before the beginning of the fights to take his place among the honored guests. He was always greeted with applause, for a name like his, along with the fame of the *toreros,* incited the crowds and gave the *corrida* a special atmosphere. Like all the other *aficionados* in the circle of the arena, he feverishly awaited the entrance of the *matadores* and their entourage. Meanwhile, the latter paraded around outside in their huge American cars with the swords on the roof, the insides of the cars stuffed with the cuadrilla's

109 Picasso in conversation with the bullfighter Luis Miguel Dominguin beneath the bronze statue *Head of a Woman,* 1941, at La Californie.

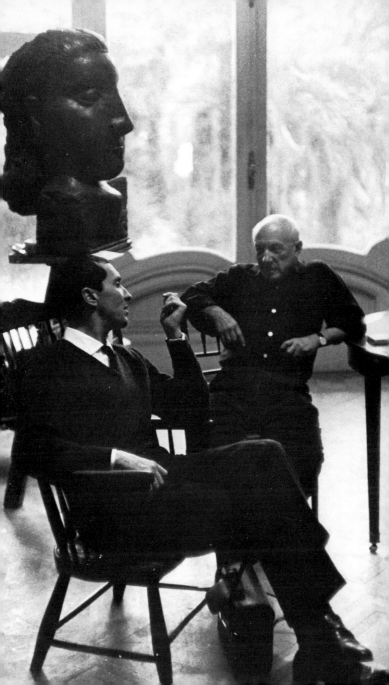

things, costumes, and the *muleta*. Picasso leaned way over the railing and excitedly awaited the arrival of his friends. He knew almost all of those famous *toreros,* Dominguin, Ordonez, Aparicio, Chamaco, Ortega, Benvenida, and the young, magnificent El Cordobes. They came to Picasso and embraced him, and the arena was filled with shouts of welcome in Spanish and enthusiastic screams in harsh Provençal. Picasso admired the *toreros'* costumes and envied them their *traje de luces,* their bullfighting suits embroidered with precious gold and silver threads. One day Dominguin came to Picasso and gave his friend one of his own suits.

I often had the experience of not being able to get into the *callejon,* the corridor between the bleachers and the barriers on the rim of the inner arena, where the view was best and I was able to photgraph the bullfight and Picasso.

One day when I was unable to obtain tickets, I waited at the bulls' corral. A dense, noisy crowd made passage impossible. Suddenly, I spotted Luis Miguel Dominguin, whom I had met at Picasso's house, surrounded by admirers. I forced my way through the crowd and explained to him that I wasn't able to get into the arena. Big-hearted as he was, he put his arm around me and slowly pushed me in front of him to the *toreros'* entrance way. Suddenly, he doubled over in pain. Someone had accidentally shoved him on his injured, bandaged hand, the one he used to wield his sword. Some officials then noticed Dominguin's predicament and let us into the arena. Afterwards, I admired Dominguin who confidently mastered all the difficult stages of the *corrida*.

Picasso usually followed the fight tensely and nervously for he was always biased toward the matador and the bull alike. He was always glad when a bull put the *toreros* in a difficult situation. When the *picadores* and afterwards the *banderilleros* came and the crowd jumped up screaming and yelling, Picasso sat motionless and tense in his seat. Once the

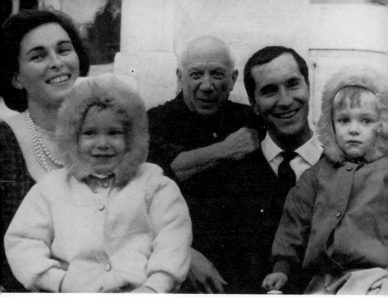

110 Picasso with Dominguin, Dominguin's former wife, the actress
Lucia Bose, and the couple's children in the garden at La Californie.

bullfight was over, he remembered every detail for a long
time, as if he had sketched everything. With a little color
and a few quick, precise brushstrokes, he was able then to
preserve every movement of the performers — their almost
ritualistic entrances, the elegance of their gestures when they
thrust the *banderillas* in the bull.

In the magnificent series *Toros y Toreros,* Picasso portrayed
all stages of the bullfight down to the *estocada,* the killing of
the bull at the end of the *corrida.*

111 Dominguin chatting with Picasso and Jacqueline before the
bullfight. ▷

112 Jean Cocteau, Picasso, Paloma, Claude, and Maja (behind
Picasso) at the bullfight in Vallauris.

113 Cocteau, Picasso, Dominguin, and Lucia Bose during a critical
moment in the fight.

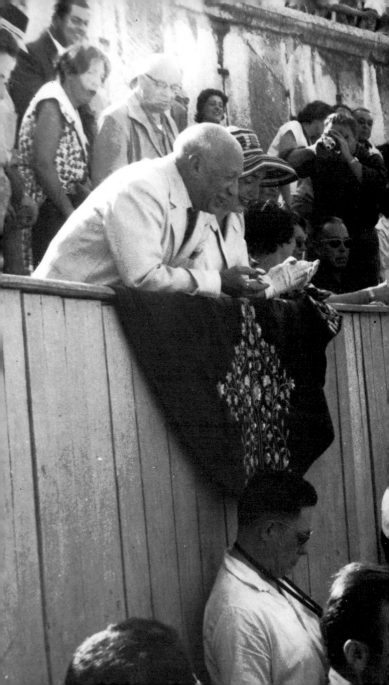

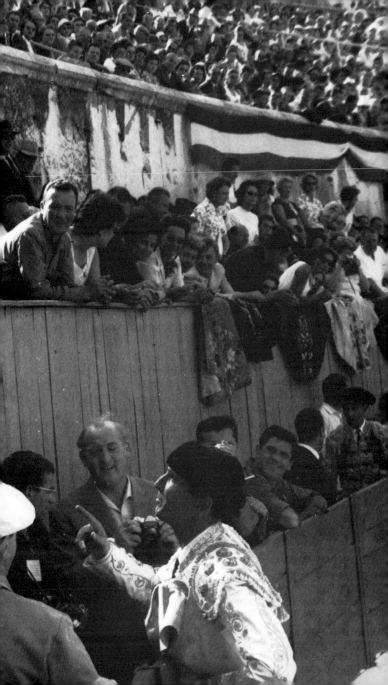

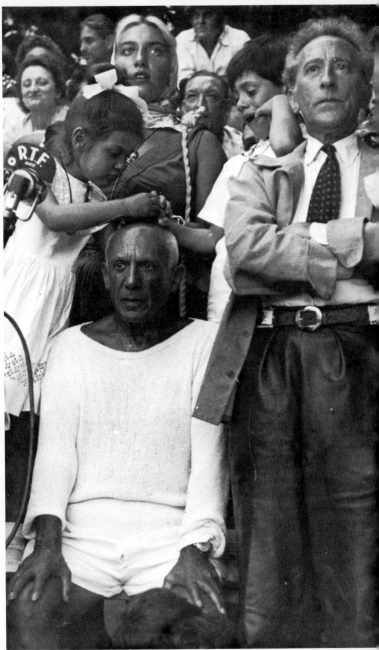

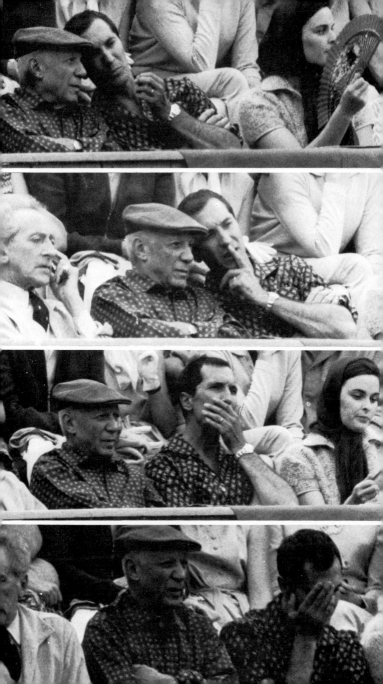

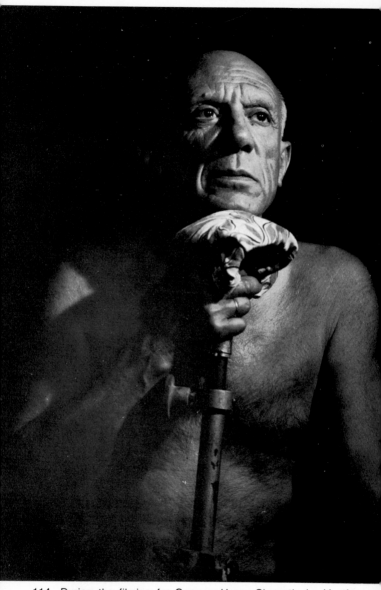

114 During the filming for Georges-Henry Clouzot's *Le Mystère Picasso*.

Posed Photos

Picasso loved photographs and always had understanding for the photographer. Thus he also strove to help him. This feeling went so far that he believed he had to do something spectacular in front of the camera so that the person behind it didn't have to go away with boring and unattractive shots.

Picasso saw himself as an interesting object to the public. Sometimes he played this role consciously and at those times he was set on appearing in the press. It made him feel secure during periods when his new work was criticized or when he himself had doubts and felt insecure. Then he sought the public and was accessible to journalists. As he became older, he recognized the absurdity of such ideas. During the final year of his life he was totally inaccessible.

He always felt flattered when something new or avant-garde was disparaged as "a Picasso." Sometimes he let himself be photographed in disguise, with a mask, a ridiculous hat, or an outrageous costume. He indeed had a secret desire to alter his identity. In a certain sense he wanted to create a new and different image for himself and he used photography to preserve this changed image. He was a born actor who could effortlessly become a comedian, a gifted clown with an extremely expressive face. Had he not become a painter, one could well imagine him acting. When he was relaxing among friends, he told the most delightful stories and usually acted them out.

It was no accident that he took an interest in circus life. When, in 1906, he lived in the Bateau Lavoir in Paris he regularly went to the Medrano Circus nearby. He valued the company of circus people. He envied them the possibility of changing their identity merely with a bit of make-up. This is probably why a few of the harlequins he painted also have his traits.

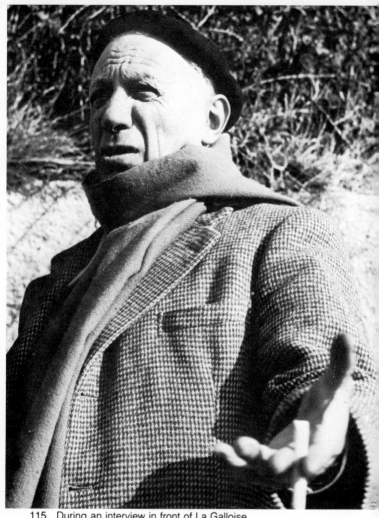

115 During an interview in front of La Galloise.

In the 1920's Picasso enthusiastically attended the masked balls of his friends. Even as an old man he continued to dress up in disguise. There were corners of his house which were crammed with hats, masks, and costumes. When he had to

116 Picasso in his bedroom at La Galloise. ▷

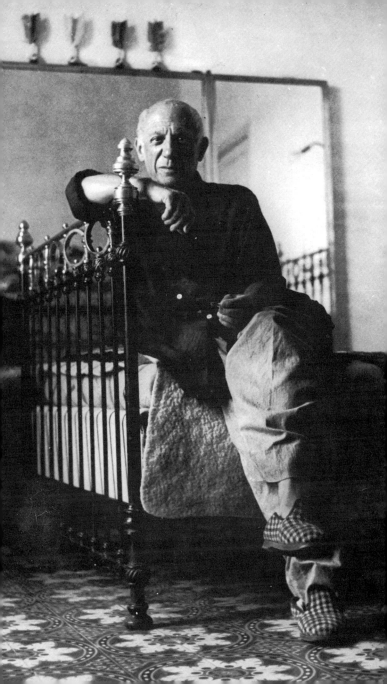

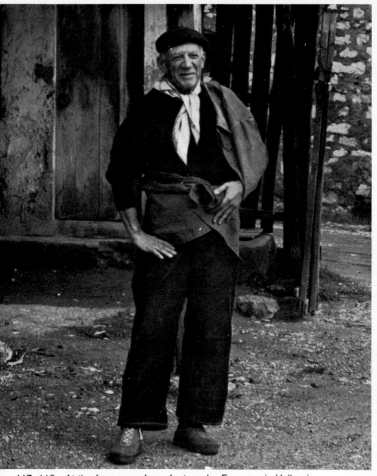

117, 118 At the former perfume factory, La Fournas, in Vallauris.

leave the house quickly, he could be seen from time to time in the streets of his place of residence wearing a bright jacket and an old slouch hat on his head. Costumes and playacting were important modes of expression for Picasso, parts of his need to create, to constantly produce the new and unexpected.

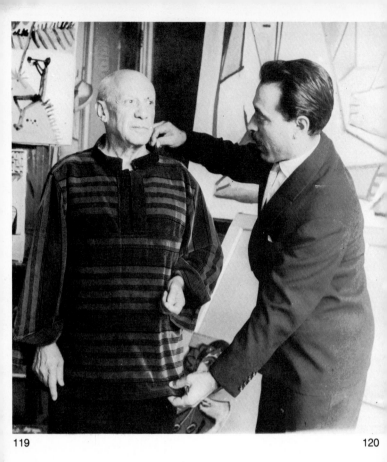

119

120

119, 120 Michel Sapone, a tailor in Nice, received small works from Picasso in payment for his services.

121–124 To strike a pose, Picasso tries on hats and caps from his collection for his own amusement and that of his guests.

125 Picasso in a whimsical costume (among other things, he has on a bullfighter's jacket) in front of the garden gate at La Californie. ▷

126 Before painting on a length of paper for the film *Le Mystère Picasso* by Georges-Henry Clouzot.

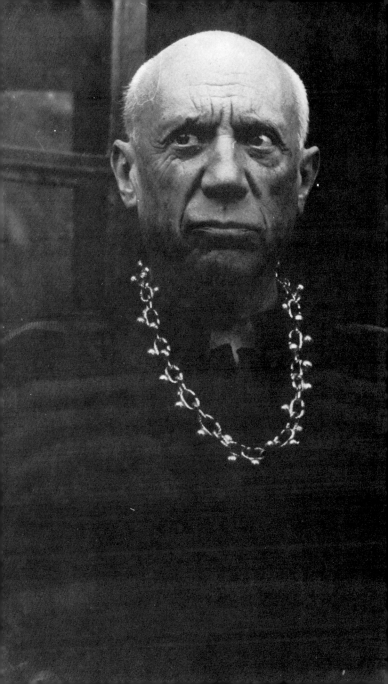

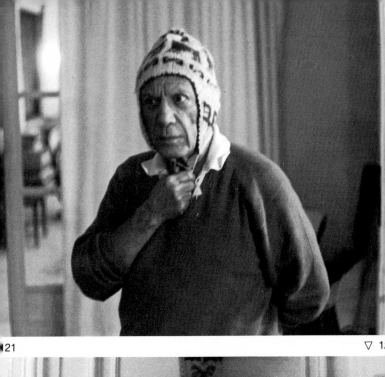

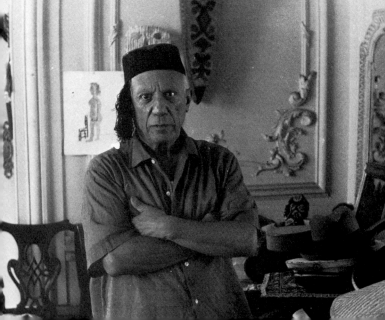

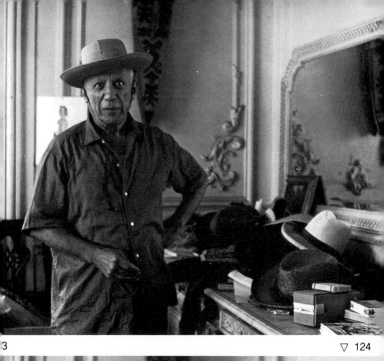

▽ 124

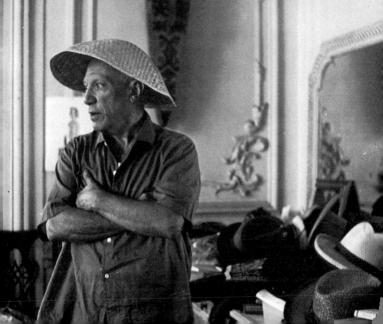

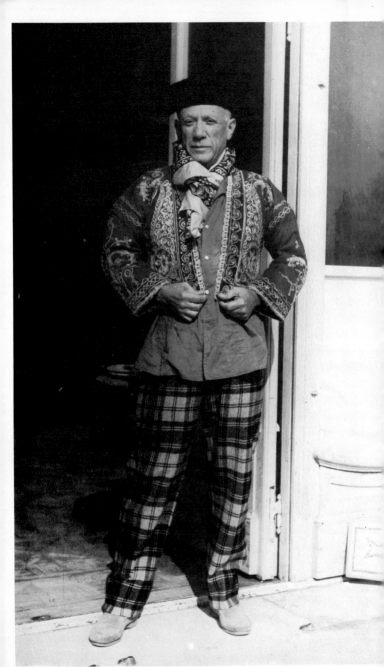

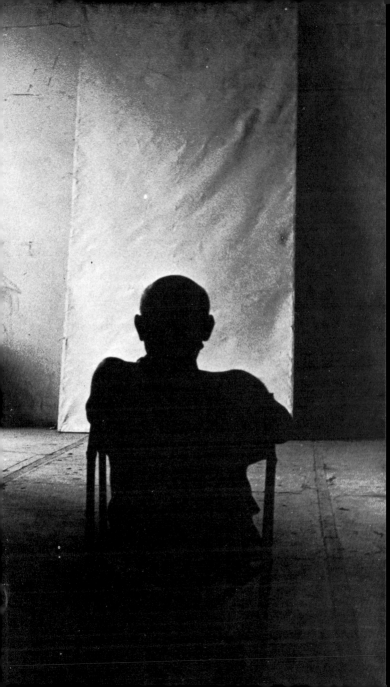

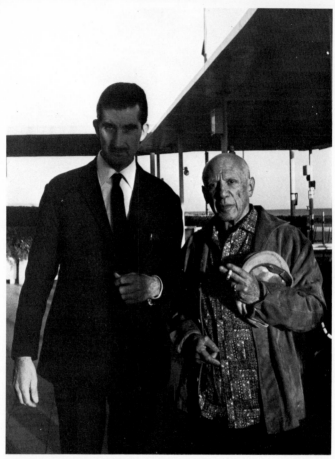

127 Pablo Picasso and Edward Quinn at Nice Airport
(photo: Jacqueline Picasso)

Biography

1881 Pablo Ruiz Picasso is born on October 25 in Malaga. His father is José Ruiz Blasco, a painter of Basque descent, and a teacher at the San Telmo School of Arts and Crafts. His mother is Maria Picasso Lopez, an Andalusian.

1884 Birth of his sister Lola.

1887 Birth of his sister Conchita.

1890 The family moves to La Coruña in Galicia. Painting instruction in his father's class at the Instituto Da Guarda.

1895 Moves to Barcelona. Picasso studies at La Lonja School of Art.

1896 His first atelier on the Calle de la Plata in Barcelona.

1897 Joins the artists' group *Els 4 Gats* along with Manolo, Gonzales, and Sabartés, among others.

1900 First publication of Picasso's works in the periodical *Joventud.* His first trip to Paris.

1901 His second stay in Paris (until January 1902).
 Atelier on the Boulevard de Clichy.
 Exhibition at Ambroise Vollard's. Befriends Max Jacob.

1901–1904 The Blue Period.

1902 Picasso once again in Paris. Exhibition at Berthe Weill's. His first sculpture.

1904 Settles in Paris permanently (in the Bateau Lavoir until 1909). Establishes contact with Fernande Olivier.

1905 The Rose Period. Series of etchings entitled *Tightrope Dancers.* Befriends Guillaume Apollinaire. His first sales.

1906 Meets Henri Matisse. Becomes very interested in Iberian sculpture and the primitive art of Africa.

1907 The painting *Les Demoiselles d'Avignon.* Befriends D. H. Kahnweiler. Meets Braque and Derain.

1908 Celebration in honor of Henri Rousseau at Picasso's atelier. His first cubist still life.

1909–1911 Analytical Cubism.

1909 Moves to the Boulevard de Clichy. His first exhibition in Germany (at the Galerie Tannhauser in Munich).

1910	Paints his famous portraits of Kahnweiler, Uhde, and Vollard.
1911	Spends the summer with Braque at Manolo's in the Pyrenees. His first American exhibition (at the Photo Session Gallery in New York).
1912	Beginnings of Synthetic Cubism. Moves to the Boulevard Raspail with his new companion, Eva (Marcelle Humbert).
1913	New atelier on the Rue Schoelcher. Death of his father.
1914	The painting *Les Saltimbanques* is auctioned in Paris for 11,500 francs.
1915	Moves to Montrouge (Rue Victor Hugo). Eva dies.
1917	Sketches for Diaghilev's *Ballets Russes*. Meets Olga Koklova and Stravinsky.
1918	Marries Olga Koklova. House on the Rue de la Boetie (given up in 1951).
1919	With the *Ballets Russes* in London. Meets Joan Miró in Paris.
1920–1922	Huge female nudes.
1920	Produces his first neoclassical paintings. The first of many summers in Juan-les-Pins.
1921	Birth of his son Paul.
1924	End of his neoclassical period. Beginning of the large still life.
1925	Takes part in the first surrealist painters' exhibition in Paris.
1931	Buys the Château de Boisgeloup near Gisors (Eure) and constructs a large atelier for sculpture. Establishes contact with Marie-Therèse Walter.
1932	Christian Zervos begins the publication of the comprehensive catalog of his works.
1933	The first volume of the catalog of his graphic works is published by Bernhard Geiser.
1934	A lengthy journey through Spain. Involvement with bullfighting scenes.
1935	Divorce from his wife Olga Koklova. Executes one of his masterpieces, the etching *Minotauromachia*. Birth of his daughter Maja.
1936	Establishes contact with Dora Maar. Traveling exhibitions in Barcelona, Bilbao, and Madrid. Outbreak of the Spanish Civil War. Picasso is appointed director of the Prado in Madrid by the Republicans.
1937	Paints *Guernica* for the Spanish Pavillion of the World's Fair. The German air attack on the Basque city of Guernica provides him with the theme. Finishes the 100 etchings begun in 1930 for the Vollard Suite.
1939	Retrospective exhibition in the Museum of Modern Art in New York. Death of his mother. With the outbreak of war, he moves back to Royan near Bordeaux.
1940	Returns to German-occupied Paris.
1941–1944	Atelier and house on the Rue des Grands-Augustins.
1941	Writes the play *Le désir attrapé par la queue* (performed at the Leiris house with the assistance of Jean Paul Sartre, Simone de Beauvoir, Albert Camus, Louise and Michel Leiris).
1944	Joins the Communist Party. Work on the larger than life-size sculpture *Man with a Lamb*, which is erected at the Vallauris marketplace in 1951.
1945	First lithographs at the Mourlot atelier in Paris.

1946 Establishes contact with Françoise Gilot. Spends many months of the year on the Côte d'Azur (Gulf Juan, Antibes, Ménèrbes). First ceramic works at the Madoura Pottery in Vallauris.

1947 Birth of his son Claude. Works in the atelier at Georges and Suzanne Ramié's Madoura Pottery.

1948 Trip to Poland for the World Peace Congress. (Visits to Wroclaw, Warsaw, Cracow.) Settles in Vallauris. Buys the villa La Galloise.

1949 Birth of his daughter Paloma. The movie *Guernica* by Alain Resnais, script by Paul Eluard. Trip to Rome and Florence.

1950 Paints *Massacre in Korea*. Work on large format sculptures of found materials (*Girl Skipping Rope, Goat*). Honorary citizen of Vallauris. Travels to the World Peace Congress in England.

1951 Moves into a new house on the Rue Gay-Lussac in Paris. Travels to the World Peace Congress in Italy.

1952 Murals *War* and *Peace* for the chapel in Vallauris.

1953 Separates from Françoise Gilot.

1954–1955 Cycle of paintings *Women of Algiers* after Delacroix.

1954 Establishes contact with Jacqueline Roque.

1955 Buys the villa *La Californie*. The movie *Le Mystère Picasso* by Georges-Henri Clouzot. Olga Koklova dies.

1957 Fifty-eight variations on Velázquez's *La Meninas*. Large retrospective exhibition for his 75th birthday at the Museum of Modern Art in New York.

1958 Marries Jacqueline Roque. Mural for the UNESCO building in Paris. Buys the Château de Vauvenargues near Aix-en-Provence.

1960–1961 Series of paintings on *Le Déjeuner sur l'herbe* after Manet.

1961 Buys the villa Le Mas Notre Dame de Vie in Mougins. Large sculptures out of tin in collaboration with Lionel Prejger.

1962 Large concrete sculptures in collaboration with Carl Nesjar.

1962–1963 Numerous paintings on the theme "artist and model."

1966 Large retrospective exhibition *Hommage à Pablo Picasso* in Paris.

1968 Series of 347 etchings on the themes of "the artist and his model," "the lovers," "the circus," and "the bullfight." Jaime Sabartés dies. In memory of his friend, Picasso donates 58 paintings to the city of Barcelona.

1970 Picasso gives the city of Barcelona a large number of paintings from his youth.

1973 April 8 Picasso dies in Mougins and is buried on April 16 in the garden of his Chateau in Vauvenangues.

BARRON'S POCKET ART SERIES

These attractive low-priced books contain an average of 100 reproductions, many in full color. Each volume 4½″ x 7⅛″, softbound.

ART NOUVEAU,
Sterner. The exotic turn-of-the-century aesthetic movement. 93 ill. (19 color), $3.50

AUBREY BEARDSLEY,
Hofstatter. Fabulous collection of his elegantly decadent illustrations. 140 ill., $2.95

THE BLUE RIDER,
Vogt. Fascinating German-based Expressionist school. 87 ill. (20 color), $2.95

JOSEPH BEUYS,
Adriani, Konnertz & Thomas. The stormy career of Europe's most intriguing avant-garde artist. 100 ill., $4.95

MARC CHAGALL,
Keller. Includes many rarely-seen examples of his early work. 92 ill. (24 color), $3.75

DICTIONARY OF FANTASTIC ART,
Kirchbaum & Zondergeld. Comprehensive guide to an increasingly popular genre. 124 ill. (39 color), $5.95

CASPAR DAVID FREIDRICH,
Jensen. The finest paperback study of Germany's greatest landscape painter. 87 ill. (24 color), $2.95

ANTONÍ GAUDÍ,
Sterner. Photo-filled study of Gaudí's landmark architectural creations in Barcelona. 95 ill. (30 color), $3.50

GEORGE GROSZ,
Schneede. Trenchant satirical drawings and paintings by a 20th century master. 100 ill. (8 color), $3.75

PAUL KLEE,
Geelhaar. Outstanding selection of works by the "thinking eye of modern art." 91 ill. (42 color), $3.50

RENÉ MAGRITTE,
Schneede. Surrealistic images both witty and terrifying. 76 ill. (16 color), $3.50

PICASSO, Photos 1951-72,
Quinn. Picasso's late career, documented in fascinating photos and text. 127 ill., $2.95

ART OF THE PRIMITIVES,
Bihalji-Merin. Thorough, colorful survey of "naive" artists around the world. 182 ill. (41 color), $5.50

REMBRANDT,
Haak. New perspective on one of the most profound of all painters. 82 ill. (16 color), $2.95

PETER PAUL RUBENS,
Warnke. The celebrated Flemish master and his dynamic compositions. 105 ill. (21 color), $3.95

KÜPPERS' BASIC LAW OF COLOR THEORY,
Küppers. Innovative illustrated guide for art students and professionals. 152 ill. (66 color), $2.95

KÜPPERS' COLOR ATLAS,
Küppers. Screen tint grids show 5500 colors obtained through various combinations and saturations. 75 ill. (48 color), $4.95

BARRON'S, 113 Crossways Park Drive, Woodbury, New York 11797